BARNARD CASTLE
SHOPS, PUBS & TRADES
THROUGH TIME

Carol Dougherty
& Paul Chrystal

AMBERLEY PUBLISHING

Acknowledgements

Acknowledgements and thanks are due to the following who have helped by providing information or images: *The Teesdale Mercury* for allowing privileged access to their wonderful archives; Durham Archives; Darlington Local Studies Library; Alan Farrar; the traders of Barnard Castle for providing extra details; Kendal Library; Erik Matthews; Nottinghamshire City Museums & Galleries for permission to reproduce the photograph on page 83; Lancelot Nelson for many of the old photographs; Laura Brown, Heritage Programme Co-ordinator for the photographs of the Witham; Amanda Armstrong, Marketing Coordinator at William Smith for the images on page 91; Alan Dougherty, Peter Perry and Pamela Womack for their enthusiastic support. And finally to the person who made it possible – Kenneth H. C. Dougherty, former resident of Barnard Castle, who spent countless hours researching these buildings, their histories and their inhabitants. Carol Dougherty, his daughter-in-law, has expanded upon his research so that the book will stand as a testament to Ken's meticulous and hard work, and will be a fond tribute to his memory.

To the memory of Kenneth H. C. Dougherty

First published 2013

Amberley Publishing
The Hill, Stroud, Gloucestershire, GL5 4EP
www.amberley-books.com

Copyright © Carol Dougherty & Paul Chrystal, 2013

The right of Carol Dougherty & Paul Chrystal to be identified as the Author of this work has been asserted in accordance with the Copyrights, Designs and Patents Act 1988.

ISBN 978 1 4456 1678 0 (print)
ISBN 978 1 4456 1693 3 (ebook)

British Library Cataloguing in Publication Data.
A catalogue record for this book is available from the British Library.

Typesetting by Amberley Publishing.
Printed in Great Britain.

Introduction

Barnard Castle has been recognised as one of the fifty-one most historically and architecturally important towns in Britain.

This book celebrates the character and ownership of many of the commercial establishments in Barnard Castle from the 1800s to the present day and reveals the history behind some of today's modern shopfronts through photographs, advertisements, and information from census returns, trade directories, newspapers and other documents.

The medieval borough of Barnard Castle was founded in the eleventh century; 100 years later Bernard Baliol built a sturdy castle – the remains of which stand today and give the place its name. A busy town began to thrive alongside the castle; market day has long been on Wednesday and in the nineteenth century the town boasted one of the largest corn markets in the North of England, drawing custom from far and wide. In the 1800s the Clerk of Corn Markets and Fairs would have been responsible for the collection of tolls and rents due from the traders at the markets and fairs. He also regulated trading pitches, the quality of goods on sale and the enforcement of weights and measures. A notice that hung on the wall of the Butter Market in the nineteenth century stated that 'Corn Returns' had to be delivered to the revenue office in Hall Street. The date of inception of a market in Barnard Castle was 1175. The first recorded mention of a fair is 1293.

The modern town can today be explored through streets, yards and back lanes – many of which are traceable to the early development of the town in the thirteenth century. Much has been written about the castle and the town's early history; this book, however, shows something of the diverse commercial, retail and manufacturing sectors of Barnard Castle and how these have developed over the last 200 years. The book also reveals changes in population, types of traders, and how prominent traders established successful businesses lasting between 60 and 100 years that often passed from one generation to another.

The population of Barnard Castle did not fluctuate in the same way as other parts of England and Wales in the 1800s, but industry, the military and tourism did have an effect, and this book demonstrates how the number of shops along with the goods and services they provided varied according to demand.

As fashions and industry changed so did commerce. For example, after a century of trading, Thompson's Clog and Patten Making folded (now No. 43 The Bank) while boot repairers flourished. The introduction of the domestic sewing machine (costing £5 10s 0d in 1880) affected the dressmaking industry as more people made their own clothing. The carpet-weaving industry – so important to the town in the early 1800s as a main source of employment – had collapsed by the 1880s as industry nationwide went into decline and unemployment increased.

The Antiques Centre is on the site of the former Mission Hall, where tea and clothes were dispensed to the needy from the former slum dwellings in Bridgegate and Thorngate – now the location of sought-after contemporary riverside apartments.

Local independent traders came up against nationwide chains such as Boots the chemist and Woolworths; changes go on today in Barnard Castle as in all towns. Some premises have seen many changes of use and occupancy, while others have shown consistency and continuity. *Barnard Castle Shops, Pubs & Trades Through Time* is the first book to provide a door-by-door survey of the commercial development of this vibrant and varied town; in so doing it provides a unique commercial and social history of one of Britain's most significant market towns. Today, as the high street faces another challenge – this time from Internet shopping – it will be interesting to see how today's businesses adapt to face that test. They could do much worse than read this book, and see how their predecessors faced up to their particular challenges...

Carol Dougherty & Paul Chrystal

About the Authors

Carol Dougherty was educated at Charlotte Mason College and Lancaster University. She has written features for *Practical Family History* and other family historical journals. She has had a lifelong interest in local history and archaeology, and regularly takes part in digs in the North of England as well as being actively involved in local history and archaeology groups. Carol is the author of the *Historic Town Trail* for Barnard Castle.

Paul Chrystal was educated at the Universities of Hull and Southampton, after which he made a career in medical publishing. He writes features for national newspapers and appears regularly on local radio and the BBC World Service. He is the author of thirty or so books on subjects as diverse as women in ancient Rome, the history of chocolate, the Rowntree family, lifeboat stations in the North East, and *Barnard Castle & Teesdale Through Time*. Paul is married with three children and lives near York.

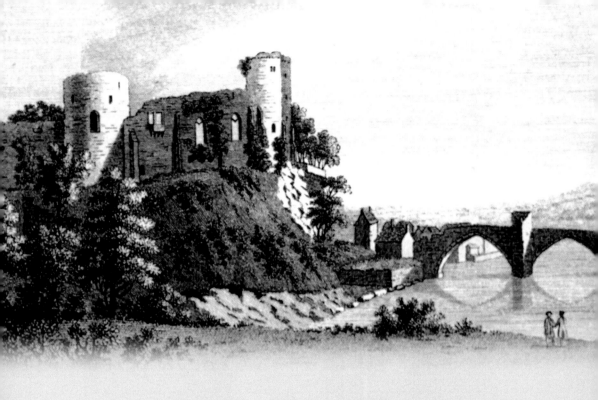

Barnard Castle

Shops, Pubs & Trades

No. 3 Market Place

These were the premises of the Bell family's ironmonger's business from the late 1840s for almost 100 years. 'Cath's Crafts' occupied the site from the 1960s to the 1990s, when it became a shop specialising in the sale of oriental rugs, carpets and camel bags. Today it is the site of Brooke's outfitters, who offer a bespoke personal service and high-class menswear. The old picture shows a view of Barnard Castle looking towards Bowes Museum. The illustrations on page 5 show the town as drawn in 1874 and the tile work that can still be seen below the window of what used to be Johnsons the butcher's on the corner of Galgate and Horsemarket.

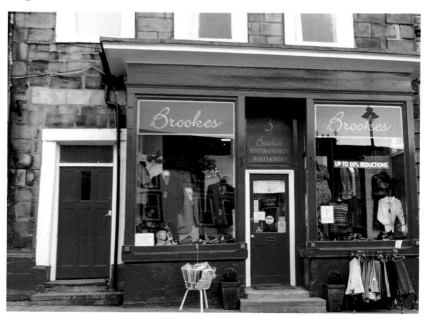

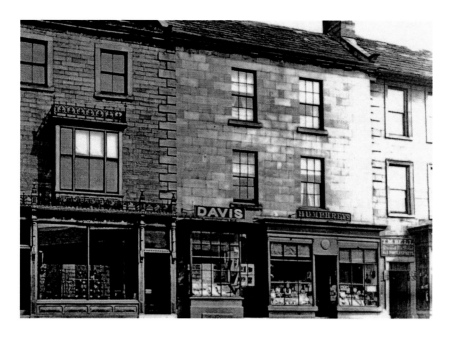

No. 7 Market Place

Thomas Clifton started his stationer's business here before 1828; it was still the family concern in the 1840s. Since then the building has been put to a variety of uses – gunsmith J. Hesketh in the 1850s; bookseller J. E. Davis in the 1870s; saddler Anthony Todd in 1890 (see also No. 13 Market Place); Burgh & Farrow architects and surveyors in 1902; Miss Jane Lee's 'Fancy Repository' in 1910; cycle agent R. G. Jackson in 1921; Turner & Heslop, electrical engineers in 1934; boot and shoe dealer T. E. Spence in 1938; a bookmaker's in 1970; Charlton's estate agent's in 2001; and today it is the site of Ruby & D. In 1879, No. 5 was occupied by Elizabeth Humphreys, silversmith, and No. 3 by T. Bell, ironmonger.

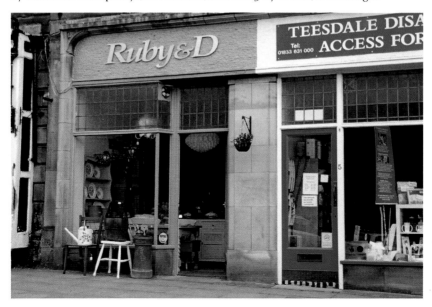

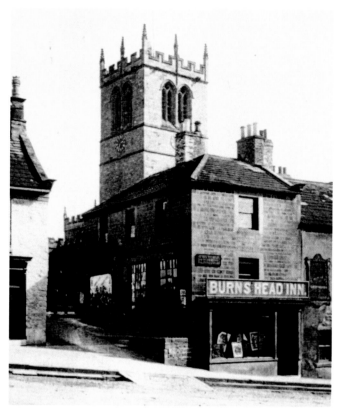

No. 9 Market Place

Spice Island Indian restaurant now occupies the site of Thomas Humphreys' clockmaking business. Humphreys was born in 1788 and had his first shop on the site of the present rose garden at the top of The Bank (the shop was demolished in 1933 to improve access to the church). He moved to No. 9 Market Place in 1842 and, after his death in 1868, his daughter-in-law Elizabeth took on the business as clockmaker and silversmith. Thomas Humphreys was the inspiration behind Charles Dickens' *Master Humphreys' Clock*. A conveyance dated 30 May 1872 indicates that Elizabeth sold to E. Dixon, cabinetmaker, while continuing to trade at No. 5 Market Place with two shop assistants. By 1891 Elizabeth was trading in her fourth shop – the site of Neville House on The Bank. E. Dixon was succeeded at No. 9 Market Place by John Wilford, tailor, John Willett who used the building as a piano warehouse, F. Metcalfe, fruiterer and R. M. and C. A. Bowes, greengrocers – until it was taken over by Spice Island. The old picture also shows the now demolished Burns Head Inn, which celebrates Robert Burns. The building to the right bore a portrait of the poet, quotations of his poetry and a picture of him ploughing.

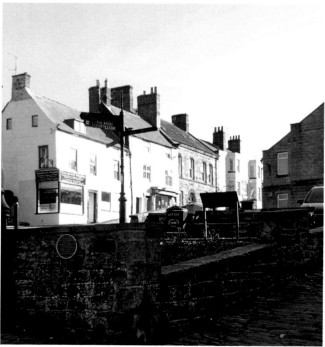

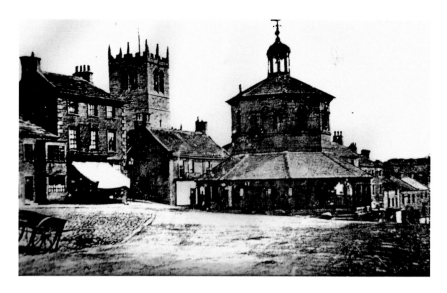

No. 13 Market Place

Thomas Pulman of Guisborough, who had established his drapery business in 1835 on The Bank, had moved here by 1851, where he employed an apprentice from nearby Lartington, and had a 'living-in' house servant. Pulman subsequently expanded into No. 11 Market Place (Pulman's Yard remains) and across to the opposite side of Market Place by 1871 (the building now occupied by Saks hairdresser's). No. 13 Market Place was taken over by confectioner H. Railton, saddler Anthony Todd (before 1890), and then for more than sixty years from 1890 it was the site of the Sayer family butchery, passing to two other butchers – Kidd and Bellwood – until eventually becoming Curlews Bookshop (along with No. 11). The older picture shows Finlay's to be where the Burns Head Inn was (*see page 21*).

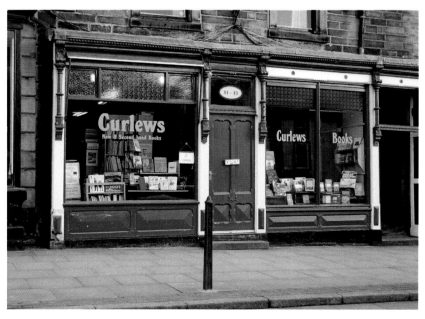

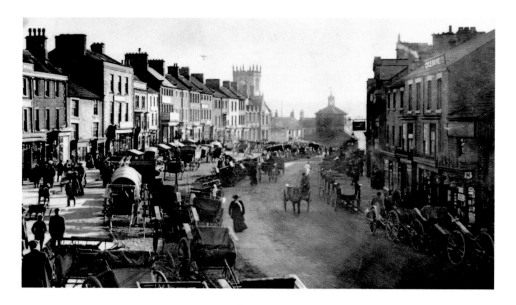

No. 15 Market Place

Once the site of T. Stephenson's hairdressing salon, it became George Burton's boot and shoe warehouse in the 1860s; his goods included 'Kid, Levant, Seal, Patent' and 'Morocco Boots and Shoes in Elastic, Buttoned and Laced'. He also offered 'Lacing Shoes, Leggings, Antigropoloes and India rubber Shoes'. William Windross, ironmonger with cycle sales and repair, took over at the turn of the twentieth century before it reverted to its former use as a hairdresser's before 1910. Beer, wines and spirits were sold from here before it became Zeta's coffee shop. Morocco is goatskin tanned with sumac shrub; antigropelos are waterproof leggings. The old photograph shows a busy Market Place on market day with the Golden Lion, C. E. Raine and Mason's on the right.

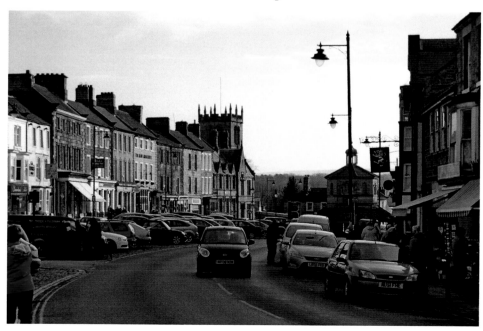

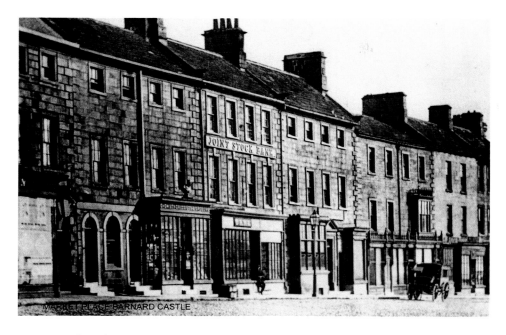

No. 19 Market Place

This building has a long been associated with financial matters. In the 1830s it was the home of the Joint Stock Banking Company, by the 1860s it was home to Darlington District Banking, by 1910 the London Joint Stock Banking Company, followed by the Midland Bank Ltd in the 1930s, for almost sixty years, until HSBC took over. Badcock's is on the ground floor to the left; note the bust above the door.

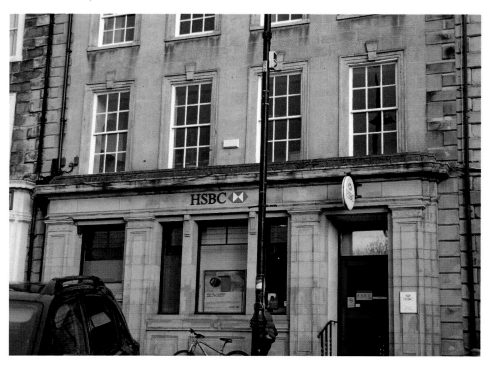

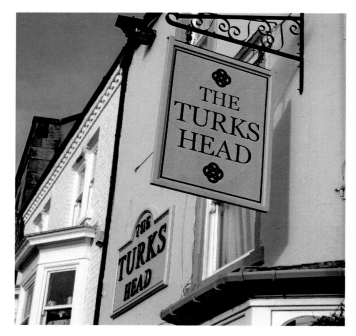

No. 21 Market Place
Druggist and grocer John Badcock of Launceston, Cornwall, started his business here in 1846 at the age of twenty-two; five years later he was doing well enough to employ three apprentices and two assistants, and to have two servants at home. Badcock would have been among one of the first druggists to see regulation of the trade. The 1852 Pharmacy Act was the first attempt at a statuary register of all pharmacists and in 1861 the United Society of Chemists & Druggists was founded. By 1871 John Badcock was calling himself a 'pharmaceutical chemist'. He died in 1877 and the business continued under his son Daniel, but the name remained 'J. Badcock & Son' until the early 1900s. After sixty years the business folded and the premises was taken over jointly by hatter and hosier Joseph Franklin and confectioners Naseby & Barker. By 1921 Lloyds Bank was in No. 21 (and No. 23), Market Place, followed by the Trustee Savings Bank, for about forty years from the early 1960s. The modern picture shows the Turks Head – one of Barnard Castle's surviving pubs; the older image is an 1896 map of the town.

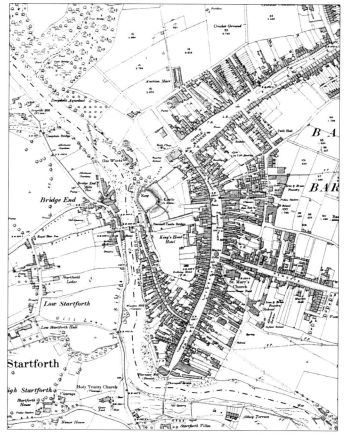

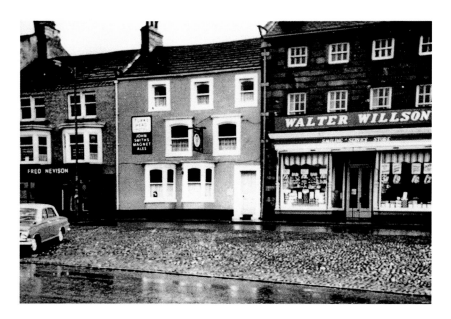

No. 25 Market Place

Grocer, carpet manufacturer and druggist Joshua Monkhouse occupied these premises from at least 1828 to the 1850s, and was followed by Richard and Elizabeth Patton selling linen ware and silks. During the 1890s Miss Merrick ran a girls' school for those 'requiring advanced tuition as day pupils or boarders'; she assured the people of Barnard Castle that 'occasional pupils may have instruction in French, German, Music, Drawing and Painting by arrangement'. By 1902 the establishment had passed to Walter Willson, grocer, and remained in this family for at least four decades until becoming the clothing outlet The Factory Store. Today the premises houses Boho Boo, pictured here with an impressive display of cupcakes. The Turks Head and Fred Nevison's are to the left.

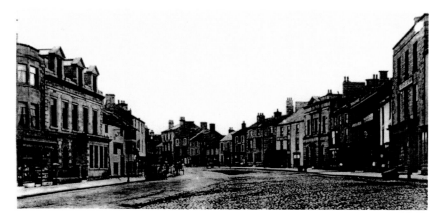

No. 33 Market Place

After a rather dramatic start to his commercial career, John Milburn Marshall of Morpeth established a very successful drapery business in town, initially a joint venture with Mr John Weatherhilt. The premises (on the near right here) was the scene of a dreadful fire on 27 March 1848 in which Weatherhilt died and Marshall had to clamber onto the roof of the building next door to escape. John Loadman leapt from one of the windows to escape but it proved to be a fatal leap. Together with his wife Jane, Marshall employed eight people by 1861, one of them a dressmaker from Northampton. By 1871 they had twenty-two people, including dressmakers from Liverpool, Lincolnshire and Scotland, and at home they had the services of a cook, housemaid, nurse and washerwoman. The availability of cheaper sewing machines may account for the fact that by 1902 there were only eleven staff members. The building later became 'Miss Mary Milner's Hotel & Restaurant', and then C. Jordison's 'Refreshment Rooms' in 1910. Moving from No. 23 Market Place, Joseph Franklin, hatter, hosier, clothier and outfitter was established here (and at No. 31) in the 1920s and throughout the 1930s. Greenwood's gents' outfitters took over, followed by Oswell's decorative household goods. Holland & Barrett are now in the premises. To the left (now Castle Cards), the much altered building dates from 1667 and first occupied by a butcher, which then more or less marked the limit of the town's commercial development. The Witham building is in the centre.

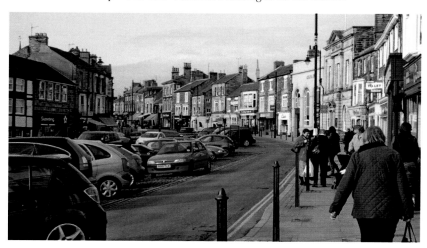

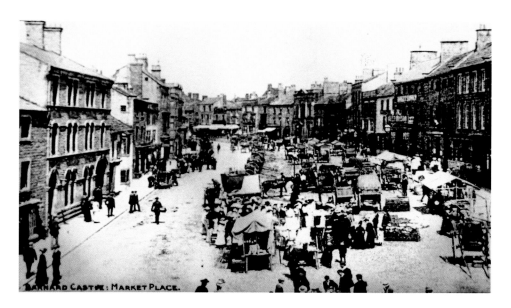

No. 39 Market Place

Before moving to No. 25 Market Place in the 1850s, Richard and Elizabeth Patton worked from here. John Hall & Son – chemist, tea seller and grocer – succeeded them, until it was taken over by Ralph Raine, another grocer and chemist. It was the site of chemist John Knowles' pharmacy in the 1920s then Boots in the 1930s.

No. 10 Newgate

The Black Horse (*see page 19*) was a departure point for carriers from the early 1800s – in 1828 Thomas and John Blackburn left every Tuesday morning for Leeds; in 1835 they added Friday afternoon departures passing through Richmond, Catterick, Bedale, Ripon, Harrogate and York. William Holborn also left the Black Horse for Houghton-le-Spring every Wednesday afternoon. The new photographs show four more Barnard Castle pubs.

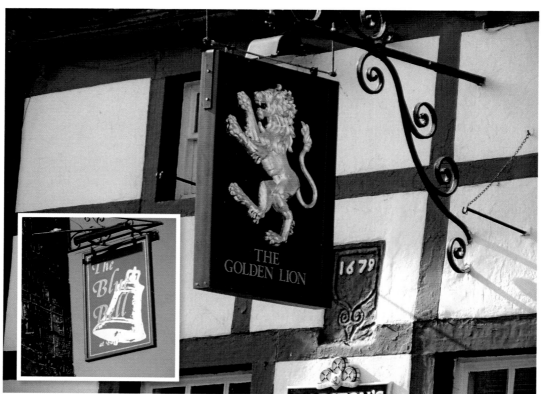

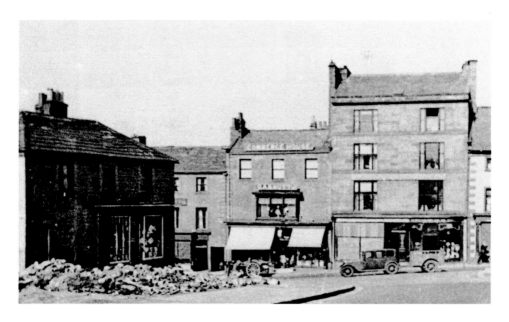

No. 22 Newgate

Owen Longstaff, flax manufacturer and partner in the firm of Ullathorne & Longstaff, was succeeded here by watch and clockmaker John Jackson around 1890; this operated from here for at least fifty years becoming a cycle agent in the early part of the twentieth century. The older picture shows a shot of The Bank from Newgate with Garbutt's in Commerce House opposite and Amen Corner demolished. The new photograph shows Allium Interiors at No. 26.

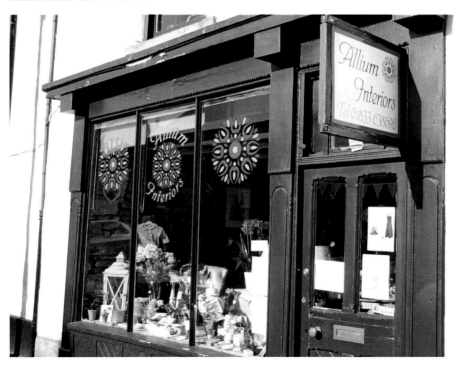

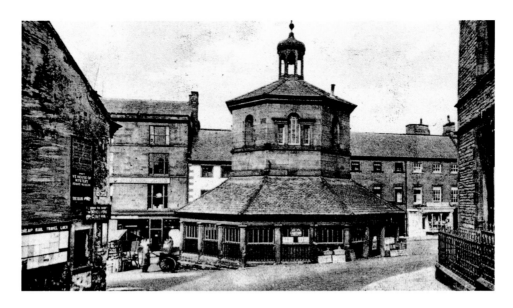

No. 26 Newgate

Sometimes called the Ancient Medieval House. An inscription in the older part of this building reads 'O remember man is mortall' – it possibly dates from the seventeenth century. Carrier William Harrison, followed by Thomas Harrison, went to London, Manchester, Liverpool, Leeds, Penrith, Darlington, Stockton and 'all parts of Yorkshire' from these premises – which was his warehouse – in the first half of the nineteenth century. Bedeswoman (a pensioner who received alms and prayed for their benefactor) Margaret Monkhouse lived here in 1873. By 1879 Thomas Borrowdale's joinery and cabinet-making business had started – it remained here until the 1930s. The building has since seen a contemporary arts studio, the Rennie Hamilton Gallery, and is currently Allium Interiors.

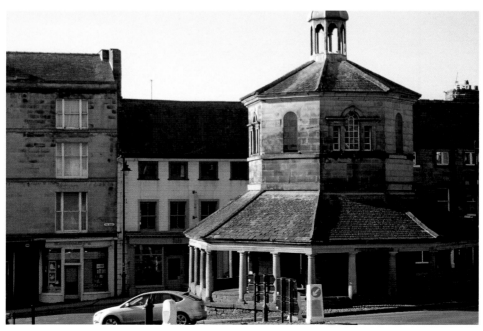

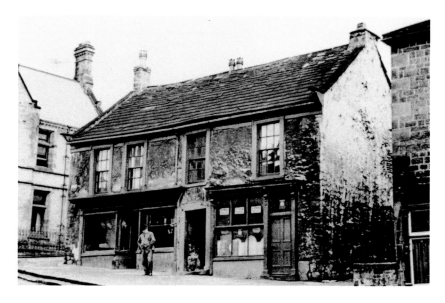

Masonic Hall, Newgate

The hall dates from 1877 and was built on land donated to the Freemasons by John Bowes. Throughout the two World Wars meetings were disrupted as the building was requisitioned for military use. In 1946 the Strathmore Lodge was formed, replacing the Barnard Lodge, and the names of some of the founders are again recognisable: J. H. Brown, grocer; W. Peat, butcher; E. Burn, greengrocer; J. W. Ascough, printer; R. Jackson, cycle shop owner. Today Masons still meet in the Lodge in Newgate. Freemasons have been associated with Barnard Castle since before the 1700s. An ancient building on Amen Corner, possibly sixteenth-century and now demolished, had a Mason's mark above the doorway, and two old buildings in Bridgegate, also demolished, had Masonic symbols carved above their entrances.

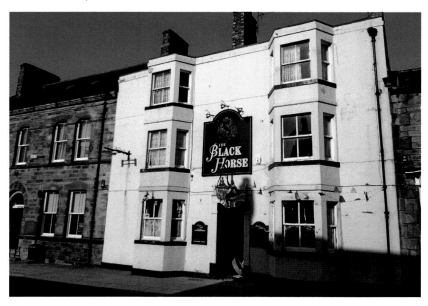

The Nest, No. 25 Newgate

Housed in what was formerly a foundry (Down's) and then a garage, The Nest is a modern gallery and Internet café. The site of the building has a much older history than the former garage, in that it was the old Bede Hospital, dedicated to the honour of St John the Baptist and occupied by three poor women who received a pension in money and coals to pray for the soul of the founder. A very early description of the Bede Hospital states that it was 'a low thatched building, containing one room only, called the bedehouse'. In 1866 the property was put in the hands of trustees. The foundry is pictured here; the Bede Hospital on page 24.

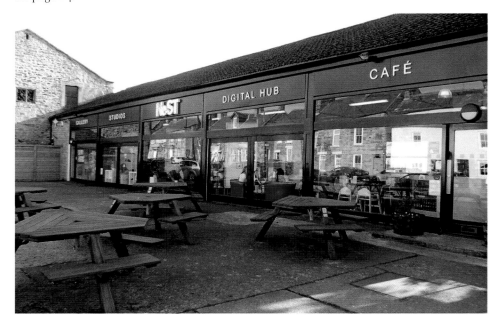

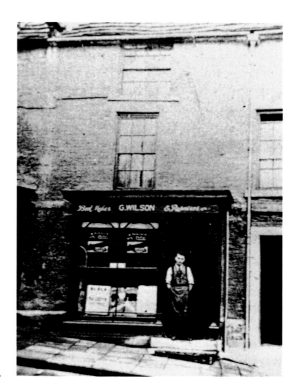

No. 2 The Bank

The earlier building here was demolished in 1934 for road improvement. Formerly on the site was clockmaker Robert Thwaites 1828–40s; grocer Joshua Maugham until the 1870s; tea dealer D. Finlay until the early part of the twentieth century and, finally, butcher R. Watson. The photograph shows the shop owned by cobbler G. Wilson at No. 7.

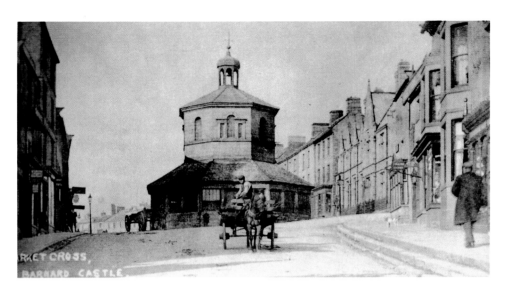

No. 4 The Bank

No. 4 suffered the same fate as No. 2. Thomas Humphreys the clockmaker worked here for almost twenty years before he moved to Market Place in 1842. James Guy, outfitter, and Matthew Borrowdale, gunmaker, were here in the 1860s and 1870s. Thomas Hutchinson, butcher, followed at the start of the twentieth century and then butcher R. Watson, who also took over No. 2. The last business before demolition was shoe repairing.

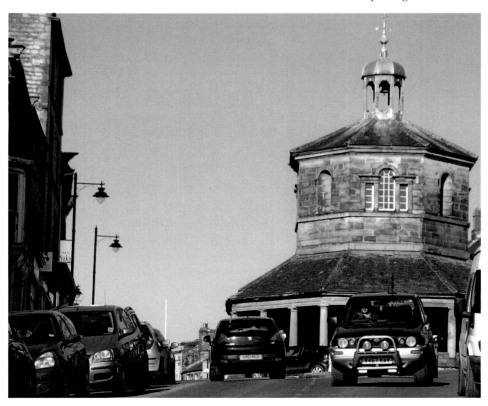

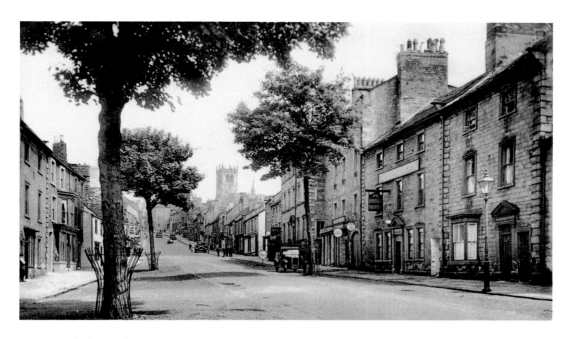

No. 6 The Bank

In 1861 Robert Buckle ensured that people could have a decent haircut in his salon and, as a perfumer, that they smelled pleasant too. Nurseryman, fruiterer and seed seller G. Metcalf took his place until the 1920s, when music seller A. Wainwright moved in. M. Scrafton, butcher, was there in the 1930s and 1940s. A pine furniture shop followed in the 1980s and Andy Beck's Teesdale Gallery now occupies the site of No. 6a. The card shows the Bridge Hotel in Thorngate, an extension of The Bank.

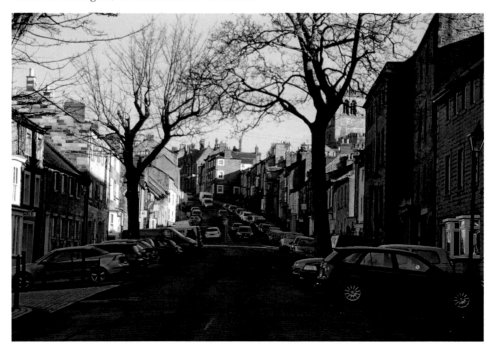

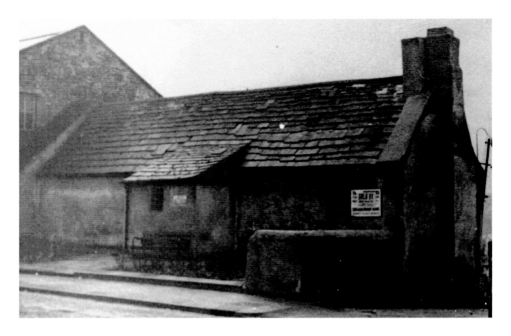

No. 12 The Bank

In 1851 baker and grocer William Metcalfe had No. 12; he was one of a long line of tradesmen here – grocer John Guy in 1861; shoemaker William Brown in 1879; confectioner Mary Milburn in 1890; china dealer G. Elliott in 1902; china dealer H. Bayles in 1934; the Zetland Café run by Miss Metcalfe in 1970; antiques Mr Hardy in 2003. It is now Grays estate agent's, which is the building that projects furthest out into the pavement. The Bede Hospital on The Bank is pictured here (*see also page 20*).

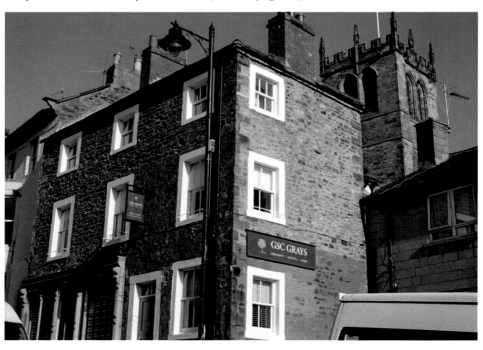

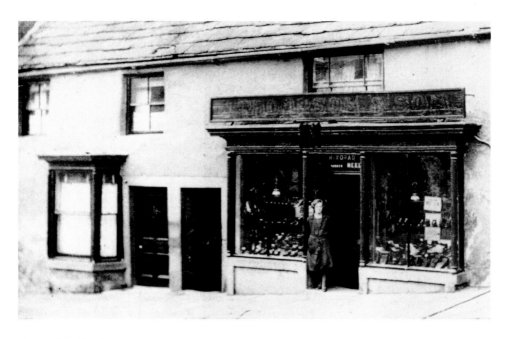

No. 22 The Bank

Now a private residence, this was the site of maltster J. Walton in 1851, brewers J. Hunt and G. Whipp 1873–1902 and yeast merchant R. Pratt until the 1940s – it seems to have had an association with beer and brewing, which lives on in its existing name of Yeast House. The old postcard shows the premises of J. Thompson & Son, boot and clog maker in a building that was later demolished. The original Mr Thompson told stories of how he talked with Charles Dickens during his visit (*see also page 41*).

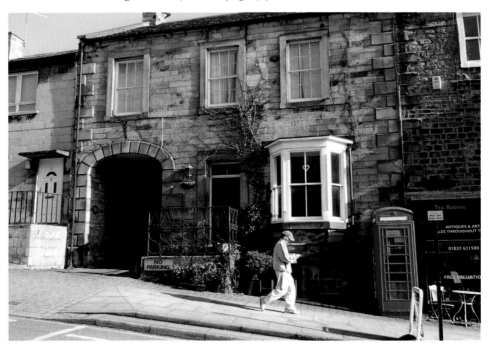

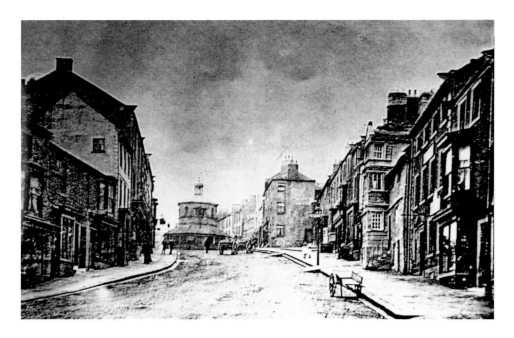

No. 26 The Bank

The site of the Rowntree's gunmakers business from the early 1800s after their move from Market Place, until Elizabeth Rowntree handed the business to gunsmith R. Simpson in the later 1870s. He was followed by joiner J. Brown; at the start of the twentieth century clog and pattern maker W. Raine was here. Confectioner Miss M. Morton followed him during the 1930s. In the last twenty-five years it was associated once again with metalworking, being the site of the Iron Man artisan blacksmith; after this Ranters sold oriental and Asian goods, then it was Spitfire Cycles. It is now a traditional cheese shop.

Nos 30–32 The Bank

Blagraves House restaurant has a long history
– from being the house of the 'Keeper of the King's
wardrobe' (the King being Richard III), to the
Boar's Head inn during the reign of Elizabeth I, it
was visited by Oliver Cromwell in 1648 *en route* to
Richmond. Later, it was the home of fishmonger
William Tomlinson in 1725, a meeting place for
followers of John Wesley and a museum known
as 'Cromwell House'. Shoemaker John Allonby
worked here in the 1890s before coal loader
Thomas Nevison in 1902. In 1921 it was converted
into apartments run by Mrs Cook. In the 1970s it
became the Cromwell restaurant, until the name
reverted to the ancient one of Blagrave. The old
card shows it during its time as J. Kavanagh's (late
Brass) rope-making business.

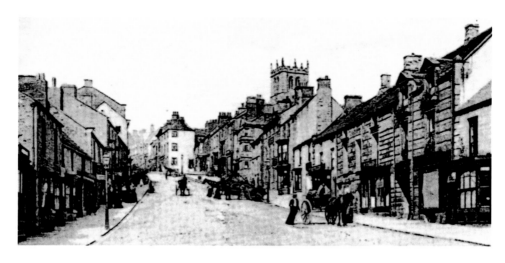

No. 34 The Bank

For over 100 years the site of today's bed and breakfast establishment was the former Shoulder of Mutton; only the names of the landlords changed – H. Pickering 1835; John Harrison Peacock 1851; Robert Hedley 1861–79 (also a smith and farrier); Elizabeth Foote 1890; Edward Robson 1902; Arthur Ayre 1910; Ambrose Morton 1921; Sidney Addison 1934 through the 1960s. In 1835 two carriers left the Shoulder of Mutton with their deliveries to Penrith – John Atkinson every Wednesday afternoon and John Johnson every Thursday afternoon. Vintage Graphics is there now with its fine picture of Heinrich Hoffman's Struwwelpeter – Shockhead Peter – on the wall.

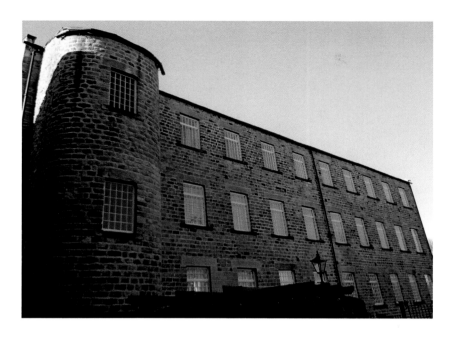

Thorngate

All that remains of this once busy and industrial part of town is Thorngate Mill and a row of weaver's cottages dating from the seventeenth and early eighteenth centuries. Today Thorngate Mill offers modern riverside living. It started life as a spinning mill in the late 1700s and throughout its long history has been put to various uses: a weaving mill, a factory producing a tiny motor car, North of England Chamois Leather Company for almost fifty years from 1935, and book sales. The site of an ancient corn mill on the banks of the Tees is a short walk away. A charter in 1410 required the townsfolk to take their corn to the Demesnes Mill for grinding; they had to pay a sixteenth of its value to the estate owners for the privilege of carrying their corn there.

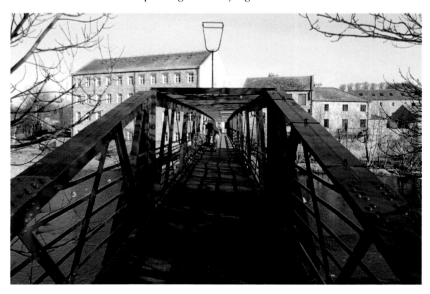

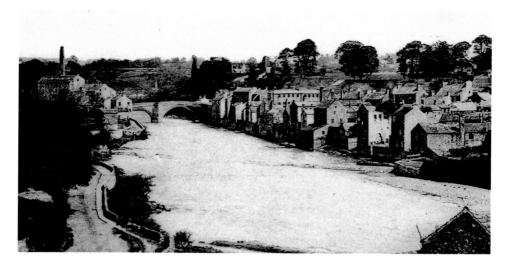

Bird Stuffing

In the 1800s there were several small traders in Thorngate – many of them moved to other parts of town from the 1830s onwards. Thomas Harrison began his bird stuffing business in the 1860s. Around 1877 he was followed by R. Carter who moved his taxidermy business to No. 40 The Bank where it continued until the early 1900s – the longevity of the trade may be accounted for by the fashion for stuffed trophies and collectables by 'naturalists' of the time. Other traders in the early 1800s included John Binks, an auctioneer who moved his business to Galgate in the 1830s; William Arrowsmith, shoemaker, who relocated to The Bank in the 1830s; J Winskill, a grocer, who moved to Galgate; Robert Wandless, cowkeeper and grocer, who moved to The Bank in the 1860s; Christopher Heslop's pawnbroker business was taken over by William Parker at No. 19 Thorngate until 1902, where he also carried on his clogging trade; Samuel Softly, hat-maker, relocated to The Bank in the 1830s. Saddler William Raine worked nearby and took on Christopher Milner as his apprentice in the late 1700s. The old picture shows the industrial side of Barnard Castle clustered along the banks of the Tees.

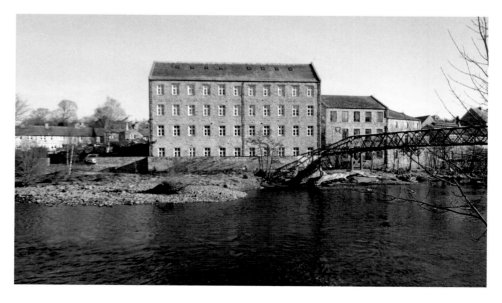

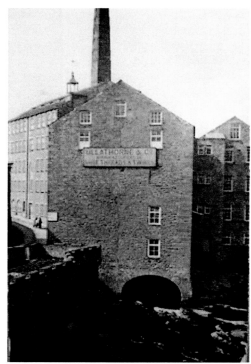

Ullathorne & Longstaff, Bridge End Mill
Established in the mid-1700s, Francis
Ullathorne's flax-dressing and shoe-thread
factory employed between 400 and 500 people
at its height. Ullathorne also had plants at
Rue Française, Paris, in Melbourne, Australia,
and at Lincoln's Inn Fields, London, where he
owned five acres, one rood and eight perches
of prime land.

DGEGATE BARNARD CASLE

The Co-op

The Co-op as we know it today began when the Rochdale Society of Equitable Pioneers established their co-operative. The group of thirty men realised that increased mechanisation was forcing people out of work as their skills were becoming redundant; consequently many families were facing poverty. The men opened a store selling their own goods at affordable prices – humble beginnings offering only flour, sugar, butter, candles, tea, oatmeal and tobacco. Distributing a share of profits according to how much was spent came to be known as the 'divi'. In 1863 the North of England Co-operative Society opened stores across the North. By 1872 it had become known as the Co-operative Wholesale Society. Since the 1950s the Co-op in Barnard Castle has been in Horse Market, but previous locations have been: Newgate and Galgate in the 1860s; Thorngate (storekeeper Elizabeth Sweeten) in the 1870s; Bridgegate (storekeeper Elizabeth Sweeten, Secretary Miss Sarah Longbottom) in the 1880s and 1890s; Nos 16 and 18 Bridgegate in 1902; premises in Nos 16, 18, 23 and 25 Bridgegate in 1910; further expansion to Nos 11 and 13 Bridgegate as well as previous premises in 1921; the same premises in Bridgegate in 1934; and also No. 4 Market Place. The old photograph shows one of the Bridgegate premises.

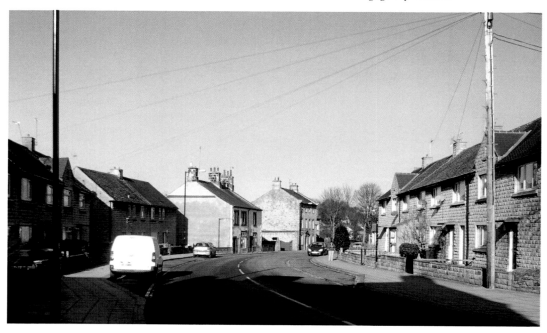

The Tripe Seller

Although the precise locations are not traceable, there were a few small shops and businesses operating here in the mid-1800s: corn and flour dealer William Hall; boot repairer Benjamin Brown; beer retailer William Coulton; coalman Thomas Raine; bootmaker Jonathan Gregory; shopkeeper Matthew Meynell; tripe merchant William Dobson; picture framer Wallace Gregory; milk seller William Sales; market gardener George Graham; grocer Charles Raine; baker William Teesdale; and butcher Robert Arrowsmith. The old photograph shows Dobson's tripe shop around 1900 with a thatched roof. There were many public houses here in the 1800s – no doubt the factory wages kept them solvent. We know the locations of four: The Blue Bell pictured here at No. 2; the Oak Tree at No. 8; Oddfellows Arms at No. 20; and the Grey Horse at No. 31. Others were the Lampton Arms, the Wellington, the Royal Oak, the New Ship, and the Weavers Arms. In 1847 the Revd George Dugard felt he had a moral responsibility to look after the 'spiritually destitute population' of Bridgegate (and Thorngate).

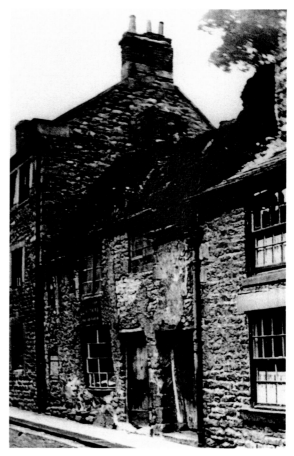

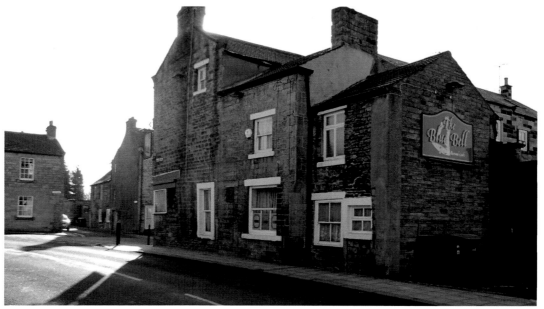

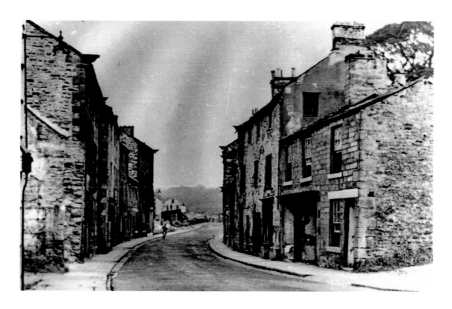

Bridgegate (River Side & Castle Side) and Bridge End

Conditions here were a far cry from the pleasant, riverside residential area it is today. In Bridgegate (and Thorngate) there was a surge of industrial development in the mid-nineteenth century. The main employers were Dunn's Carpet Factory, various worsted and twine-weaving factories, stocking factories, leather works and Ullathorne's Mill. Bridgegate is one of the oldest parts of Barnard Castle – most of the former buildings were demolished in the 1950s to widen the narrow road and provide new homes – and it was one of the poorest. It was a slum area with open drains, from which 'the stench was very offensive' according to the Board of Health Report of 1849. A report in *The Times* in 1850 described one house as 'notorious for unhealthiness', where in three years there had been nine deaths, where 'typhus prevails' and where there was always an 'accumulation of filth in the cellar'. It ended by declaring that 'in this house there occurred three cases of cholera, all of which proved fatal'.

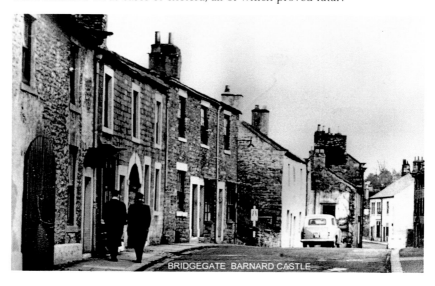

BRIDGEGATE BARNARD CASTLE

Bridge End

The houses here, known as 'Flax Fields', bear testament to Bridge End Flax Mill, which once stood here. Jonathan Rutter, bell hanger and whitesmith, lived and worked in Bridge End for more than forty years in the mid-nineteenth century. The eighteenth-century poem 'The Barnard Castle Tragedy' by J. Ritson of Stockton tells the story of how John Atkinson of Murton, servant to Thomas Howson, a miller of Bridge End, courted Elizabeth Howson who was Thomas's sister. Elizabeth believed the courtship was leading to marriage but Atkinson 'by his wheedling Solicitations, left her disconsolate, and made Courtship to another [...] and, by the treacherous Advice of one Thomas Skelton', married them 'to save the Priests Fees', in the recesses on the bridge. Elizabeth apparently bled to death, dying of a broken heart. 'Being both true and tragical, tis hopd twill be a Warning to all Lovers.' The advert shows shoemaker's R. B. Morton after its move from Bridgegate.

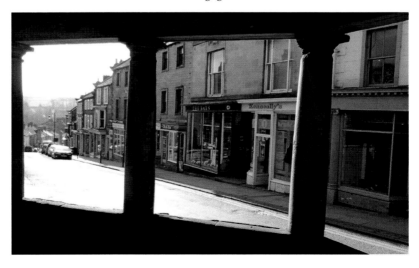

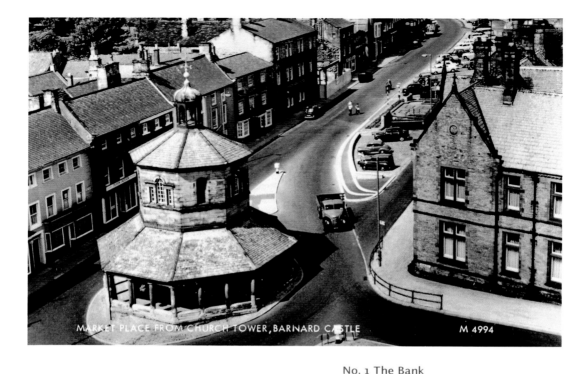

Market Place from Church Tower, Barnard Castle M 4994

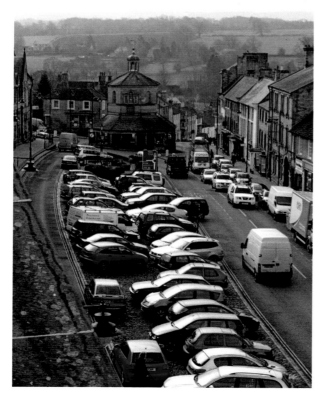

No. 1 The Bank

Drapers Thomas Pulman and John Marshall both started here before they moved their businesses to Market Place. They were followed by another draper, William Wright. Seed merchant John Coates was operating his business here by the 1870s. For about twenty years the premises were shared: first by John Byrne, tailor, and Railton's Confectionery (see also Market Place), and then by hairdresser tobacconist A. Armstrong and R. Morton, shoemaker, in the 1890s. James Stokeld, another draper, moved in during the early twentieth century, but by 1910 Mrs Mary Peart was running her 'Fancy Repository' from the premises. Baker F. E. Colley was here for a short while in the 1920s and '30s; by 1934 he had also moved to Market Place. The North Eastern Electrical Supply Company took over from F. E. Colley and from the 1980s it has been a hairdressing salon – Kenneally's – visible through the pillars of the Buttermarket on pages 35 and 37.

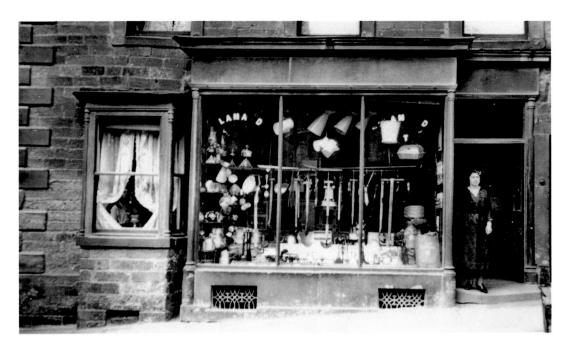

No. 3 The Bank

Draper J. Weatheritt ran his shop here in 1841. In 1851 John Bayles clearly was a busy man: he was running a business encompassing 'Carpentry, Cabinet Making, Joinery, and Dealing in Timber, Bar and Sheet Iron'. The premises remained with the Bayles family until at least 1934 – finally as leather merchant H. R. Bayles. Then there was a move to No. 12 The Bank, where Bayles became a china dealer. In the 1950s, No. 3 was the Baliol Café; in the 1980s it was Robinson's Linens, and then for a short while All Things Books. Now it is The Barn. The old photograph shows No. 7 The Bank selling lamps (note the figure in the window to the left), while the newer photograph shows The Barn.

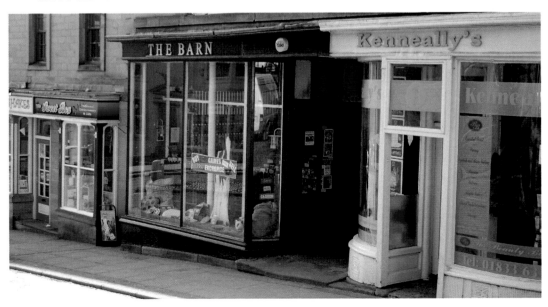

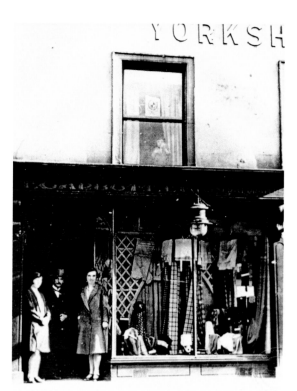

No. 5 The Bank

Surgeon H. Benning was practicing at No. 5 between 1828 and 1851; in the latter years he had been joined by a partner – Dr Slader. P. Imeson, draper, had a short spell here before the premises were taken over in 1873 by T. Garbutt, also a draper. This family business remained for sixty years – becoming T. Garbutt Ltd in 1921. In later years the premises have been used by a linen shop and a crystal seller. No. 5a is now The Sweet Box, selling traditional confectionery. The old photograph shows the shop when it was Garbutt's.

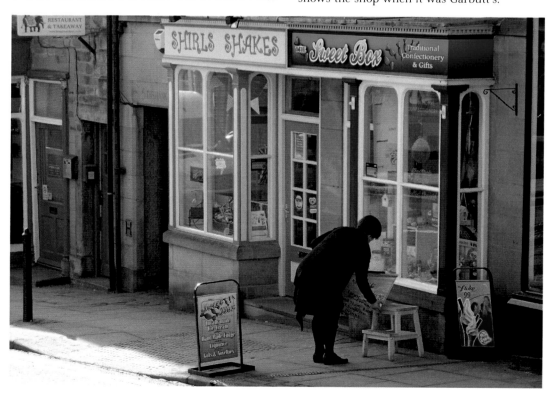

Nos 9–11 The Bank

Connolly's toy shop has been run by the family for over forty years. Previously, No. 11 was the site of the Gibson family chemist-druggist-grocery business for almost sixty years until the 1890s, when the post office moved in. In the 1930s it was the meeting place of the British Legion. No. 9 was the family-run boot and shoe repair business G., J. M. and G. C. Moore for eighty years from 1851. J. Ascough ran his toyshop here in the 1930s.

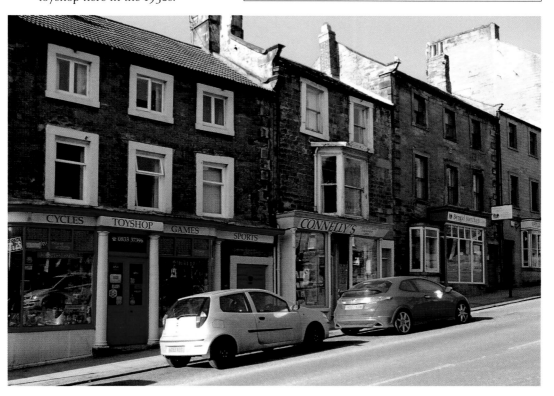

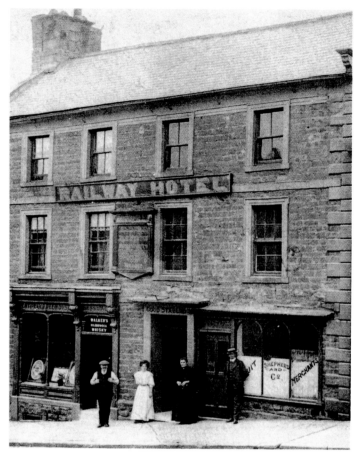

No. 29 The Bank
Claire International, Designer Knitwear Shop, is on the site of former grocer-draper A. Thompson. Butchers W. Smith and R. Arrowsmith were on the site in the latter half of the nineteenth century until 1910, followed by fried fish sellers E. Barker, F. Barker and R. Ross. The old photograph depicts the Railway Hotel on The Bank, which was nowhere near the railway (it gets its name from the navvies who stayed there when the railway was being built). The hotel was originally called the Ship Inn and later became the Old Well after the ancient well in the cellars.

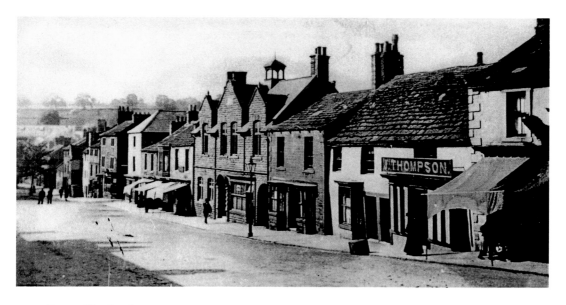

No. 43 The Bank

Earlier buildings that stood on the sites of Nos 39–45 The Bank were demolished and replaced with housing. James Thompson's clog and patten making business, which had been there, is an example of a long-running family concern – the business was in operation by 1828, and 100 years later J. Thompson & Sons were still making boots on the site (*see also page 25*).

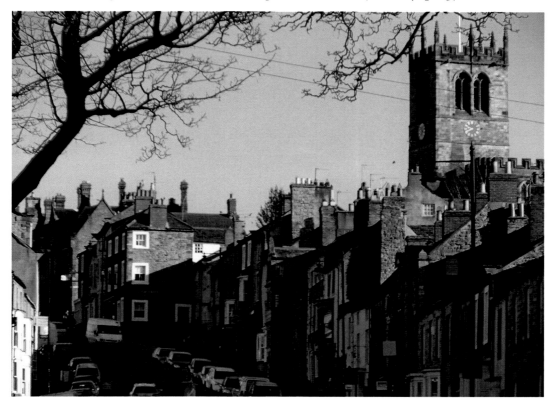

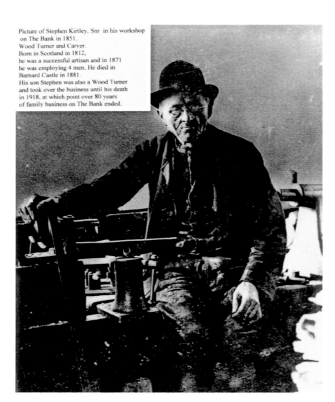

Picture of Stephen Kirtley, Snr in his workshop
on The Bank in 1851.
Wood Turner and Carver.
Born in Scotland in 1812,
he was a successful artisan and in 1871
he was employing 4 men. He died in
Barnard Castle in 1881.
His son Stephen was also a Wood Turner
and took over the business until his death
in 1918, at which point over 80 years
of family business on The Bank ended.

No. 51 The Bank

Woodturner and carver Stephen Kirtley turned and carved here for fifty or more years until the 1880s. Then it was the site of the Mission Hall, providing sustenance to the poor and needy of the town. The Job Centre had also been here. Today the Mission Hall Antiques Centre is a joint venture of five antique shops with over thirty displays of jewellery, furniture, clothing and collectables. The plaque is on the corner of The Bank and Newgate, originally on a building now demolished. Humphreys' other plaque is at No. 9 Market Place.

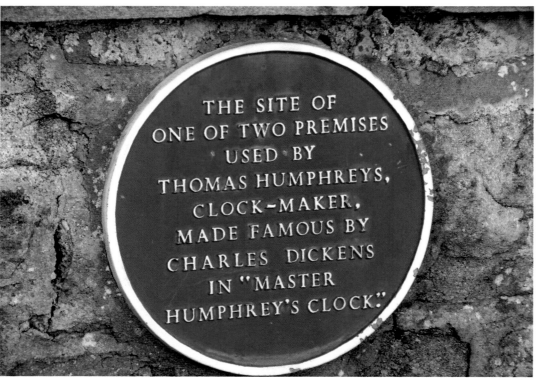

THE SITE OF
ONE OF TWO PREMISES
USED BY
THOMAS HUMPHREYS,
CLOCK-MAKER,
MADE FAMOUS BY
CHARLES DICKENS
IN "MASTER
HUMPHREY'S CLOCK."

No. 55 The Bank
Clogger John Carnell worked here in 1841, followed by whitesmith Michael Raine in 1851 and grocer William Colling in 1861. For about seventy years the Ascough family ran several types of business – carpet weaving, printing and confectionery.
Mrs Peden ran a small grocery business. Nowadays Mon Petit Spa offers massage and beauty treatments. The advertisement shows Walton's costumier at No. 35 in 1921.

Edwin O. Walton,

Ladies' & Gent.'s Tailor . and Costumier. .

Ⅲ

Pantaloon and Breeches Maker.

Ⅲ

Ladies' and Gent.'s own Material Made :: Up. ::

¶ If unable to pay us a personal visit, please send us a post card.

— o — o —

35, The Bank, Barnard Castle.
(Opposite Blagrove's House).

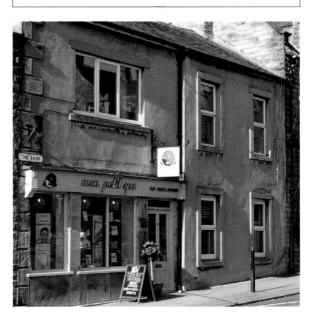

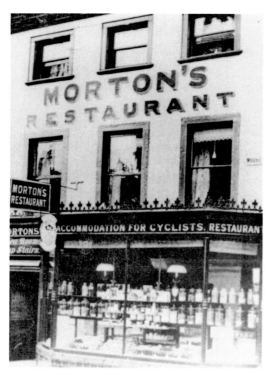

No. 4 Market Place

Boot- and shoemaker Joseph Brown worked here for more than twenty years until umbrella maker John White took over in the 1870s. By 1890, G. Morton, a carpet weaver, also ran coffee rooms here until Mrs Golightly's dining rooms were established in 1921. Between 1934 and 1938 the building was taken over by Darlington & District Co-op. Butchers & Beavers Tea Rooms were here in the 1990s; today it is Penny's Tea Rooms. Note the fine ironwork and the focus on the cyclists' market in the older photograph.

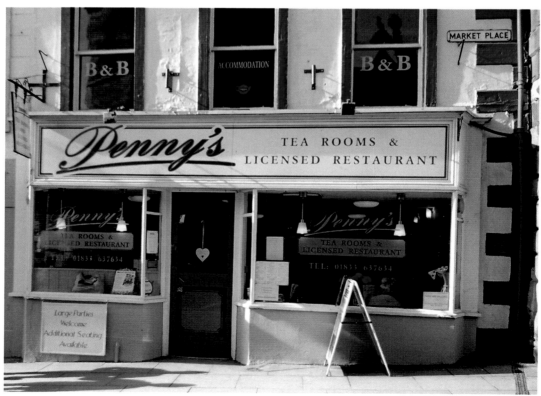

No. 6 Market Place

Grocer and tea dealer E. Tilburn had moved from No. 5 Market Place to No. 6 by 1861, and the family business operated here until into the 1900s. Frederick Foster, another grocer, was running his business here in 1921, followed by yet another grocer, Parkin Jackson. In 1970 it was hair stylists F. Parker, then Travel Care, Co-op travel services. Currently Castle Pizza is established here.

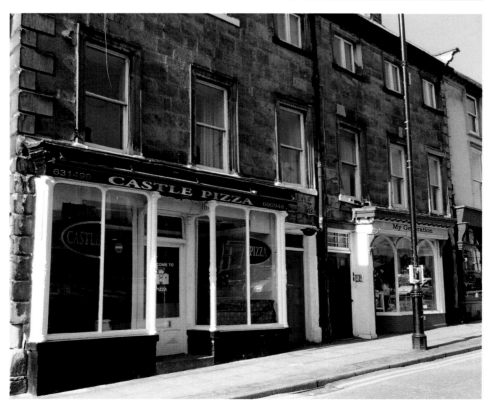

No. 8 Market Place

Silversmiths Michael Wilson and Thomas Wilson (also watch- and clockmakers) worked here from the 1840s to the 1860s. Over the next 100 years they were followed by John Byrne, draper and tailor; Mary White's millinery shop; G. Addison, draper; C. Barber, fishmonger; G. Metcalfe, confectioner; and Nicholson's Electrical Goods. It is now My Generation, eco chic boutique.

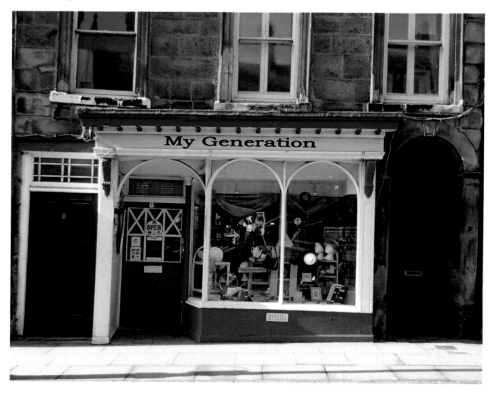

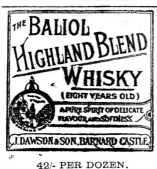
No. 10 Market Place

A private residence in the eighteenth century (as was No. 12). Mrs Elizabeth Watson, a widow, ran a linen and woollen drapery here in 1828. Some time after 1835 the premises changed hands to grocer and tea dealer Jonathan Dawson, who moved from Newgate; he and his son were still trading here in 1902, some sixty years later. In 1910 Addison and Woodhams had their grocery store, also selling wines and spirits; they operated here for another sixty years. In 1939 it was owned by the aptly named F. Beer and W. Cheesebrough. The current traders are Antique Pine furniture retailers, furniture design services and decorative furniture suppliers.

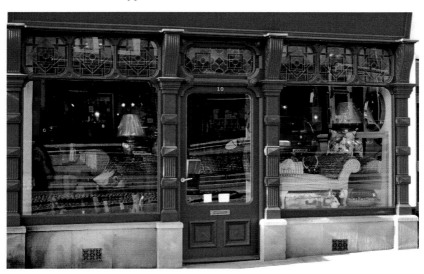

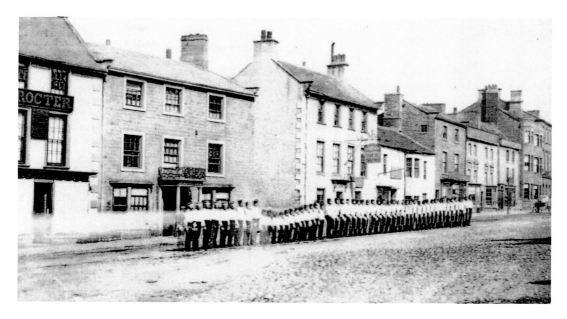

No. 12 Market Place

Originally part of a private residence (as was No. 10), for more than 100 years these premises housed several druggist-grocers: Joseph Procter, 1828; Harrison Procter, 1841; Joseph Procter, 1851; C. B. Martin, 1861; T. Illesley, 1890–1934. When Illesley moved to Newgate, bakers F. E. and S. Colley moved in, and sometime after 1938 removed the shopfront and replaced the windows. Today Robert Mottershead, optician, runs his business here. The postcard shows the militia parading – part of a long association the town has with the British Army.

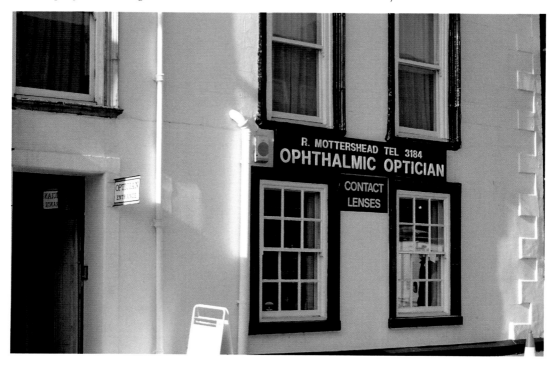

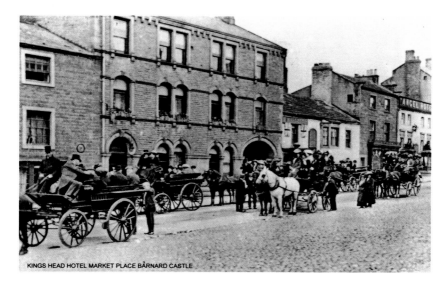

KINGS HEAD HOTEL MARKET PLACE BARNARD CASTLE

No. 14 Market Place

The Kings Head was the excise office where A. and J. Harrison ensured fair tax dealings on various commodities, the distribution of relevant documents for certain trades, and licensing during the first half of the nineteenth century. Excise duty was levied on many products – the list constantly changing – but duty on brewing and distilling was a major part of the work; beer was tested for alcoholic content and duty levied accordingly. The Excise Officer was required to keep a detailed journal outlining duty paid and received. In the 1860s, Ann Harrison also ran a posting office from here. The Kings Head was visited by Charles Dickens in 1838. While he was here he is understood to have talked to several local people and from these conversations created 'Dotheboys Hall' in his novel *Nicholas Nickleby*. The newer photograph shows the view of the castle from the rear of the hotel.

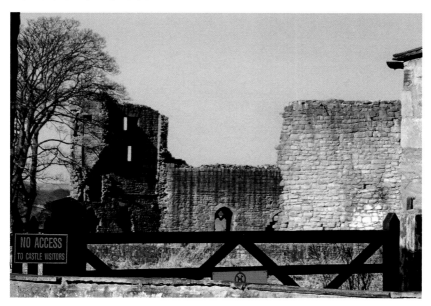

NO ACCESS
TO CASTLE VISITORS

at our up-to-date Stocks when buying for Your Home

KIPLING FURNISHING LTD.

2, MARKET PLACE, BARNARD CASTLE
PHONE 2020

No. 20 Market Place
Printer and bookseller Thomas Clifton ran his business here from 1828 and at least up to 1851. John Walker had a saddlery business here for a short while, followed by J. Guy, a grocer who traded for at least thirty years from around 1878. He died in 1936 aged eighty-five and his nephew J. P. Hunter took over the business and offered 'ground coffee – a speciality'. Zara Countrywear now trades here. The advertisement shows Kipling's at No. 2 in the 1960s.

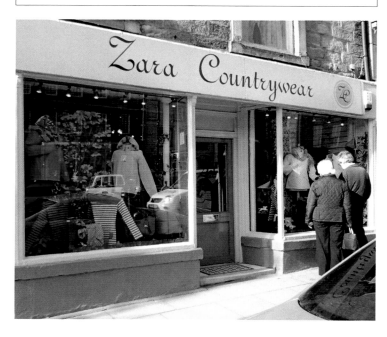

No. 22 Market Place

The building that now houses Heron Foods was built on the site of a former public house, the Angel. In 1835 it was the departure point for several carriers: John Cleasby, John Dent and John Hilton left every Wednesday afternoon for Bowes, Brough and Appleby; John Young to Newcastle every Monday; John Gibbon every Wednesday to North and South Shields; and John Wharton to Wolsingham on alternate Wednesdays. In the 1870s Thomas Awde sold agricultural implements at the Angel every Wednesday, offering ploughs of every description, harrows, drills, sheep racks, turnip cutters, sheep and oil cake mills, chaff cutters, pulpers, steaming apparatus for cattle, washing and wringing machines, churns and 'every other implement in the trade'. The 1930s saw the arrival of Woolworths and the demolition of the old building. Woolworths ceased trading in 2008. The old postcard shows the other side of the street with Walter Willson, the Waterloo Hotel and Milner's prominent. Note the Van Houten advertisement in the distance (*see page 63*).

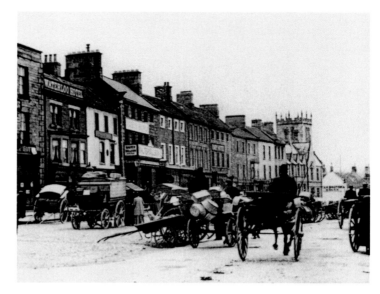

51

No. 24 Market Place

Watchmaker Reuben Railton worked from these premises in the 1870s and 1880s, where he also stocked 'Fishing Tackle of every description'. The history of this establishment is characterised by the printed word. In 1828 John Atkinson, printer and bookseller, offered circulating library facilities and stamp distribution by 1835. In the early part of the nineteenth century there were very few newspapers in circulation and the few that there were could only be afforded by the fairly well-off. Illiteracy apart, the main reason for this was the government tax of fourpence on every newspaper – essentially putting newspapers out of the reach of the working classes. In 1836 this duty was reduced to one penny and in the 1850s it was abolished altogether. With his brother, Reginald W. Atkinson, the printer and bookseller, John Atkinson published the *Teesdale Mercury* (known then as the *Teesdale Advertiser*) in 1854, no doubt sensing a business opportunity in the wake of the abolished newspaper tax. The offices were established by 1880 – where they remain to this day.

No. 42 Horse Market

'Temperance Societies inculcate the principles of sobriety, assist materially in the dissemination of religion, science, literature and in the improvement of the morals, health and circumstances of those whom they are the means of drawing from the reckless path of dissipation.' White, 1828.

Fortunately, for residents intent on following this reckless path there was a hope of salvation: the Lee family ran the Temperance Hotel at this address during the 1860s and 1870s. It was also where J. M. de Lacey, a dentist from Darlington, visited on Wednesdays during 1875 and offered 'Artificial teeth, quality and construction unsurpassed – with every recent improvement'. By a twist of fate these premises became the site of the 'Ale, Porter and Stout Bottling' business run by George Carter in the 1880s. Carter Brothers continued until the 1960s when they added haulage to their business. Subsequently, No. 42a has become hairdresser's called A Cut Above, No. 42b Castle Café and No. 42c Accent Beauty Salon.

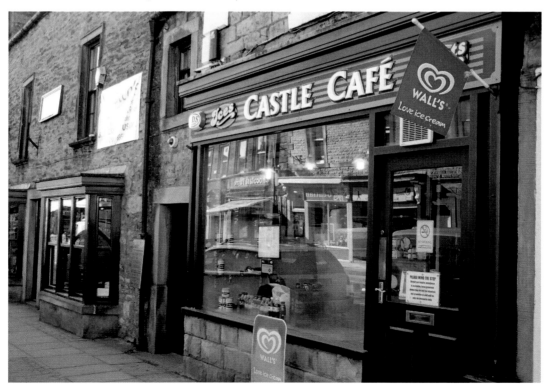

No. 40 Horse Market
This building appears to have some connection with No. 38 in that the following doctors practised here from 1873 to 1879: Doctors Groom, Coachman and Robert Wardle. This role was taken over by William Coulthard in the 1890s. By 1921 a person employed as Dr Gardener was living here – and did so until at least 1950. Wilkinson's sporting guns/fishing accessories has been established in the premises for many years. The advert is for Cunard's agency, run by Parkinson's at No. 28.

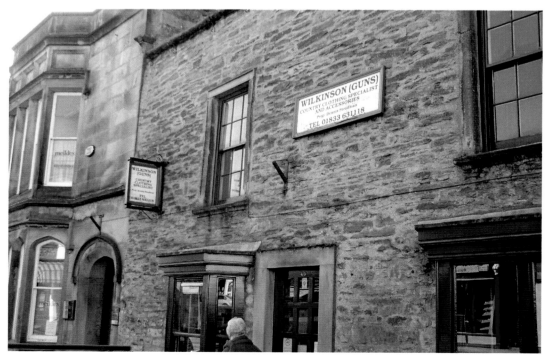

No. 38 Horse Market

This building was the surgery where Doctors Cust, Mitchell, Sevier (a Russian-born British subject) and Leishman tended to the sick of Barnard Castle for more than 100 years between 1851 and 1960. It is now Meikles solicitors. All sorts of medical remedies are advertised in the old picture.

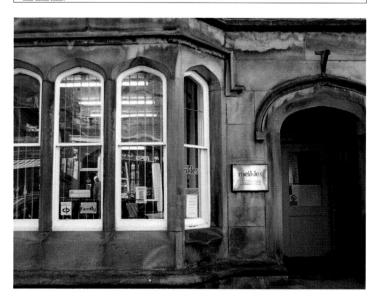

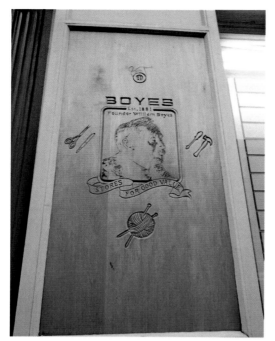

Nos 28–30 (and No. 32) Horse Market
Cabinetmaker George Monkhouse worked here during the first half of the nineteenth century and was followed by another cabinetmaker, John Nevison, in the second half of that century. Miss I. Pigg was selling 'Fancy Wools' in 1910, but by the 1920s J. Parkinson & Son, drapers, house furnishers and auctioneers of Sedgefield and Bishop Auckland, were establishing their business here and into the building next door. John Parkinson also took on the role of local agent for the Cunard Steamship Company of Liverpool and ran his office from the same building as his drapery store (*see page 54*). His businesses prospered until 1983 when the property was sold to William Boyes and Co., which still operates there and in No. 32, where Jessamine Eales and Jessie Colt made and sold their straw bonnets in the 1870s and 1880s.

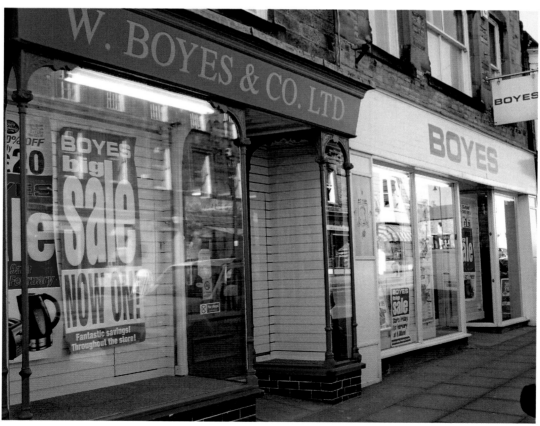

No. 26 Horse Market

What is now Barnardo's charity shop started out in 1861 as the premises of printer and bookseller Sidney Harding. R. Barker took over the same business in the 1870s; by the late 1880s he had become a corn merchant. Misses J. and L. Barker then ran a curious combination of both previous trades – corn and flour merchant's, and bookseller's.

A. Barker dropped the bookselling and was once again operating as corn and flour merchant in 1910. In 1922, E. Sheppard began a drapery business; in 1938 it was where the Halifax Building Society located local agent J. Noel Paul. In 1981 Partners was established here – a bijou department store and delicatessen. Parkinson's at Nos 30–32 is advertised in the older picture.

FOR QUALITY FURNITURE

CORTINA

**WE INVITE YOU TO WALK ROUND OUR
EXTENSIVE MODERN SHOWROOMS**

JOHN PARKINSON & SONS
(Barnard Castle) Ltd.
30/32 HORSE MARKET
BARNARD CASTLE

Established 1870 Telephone 2233

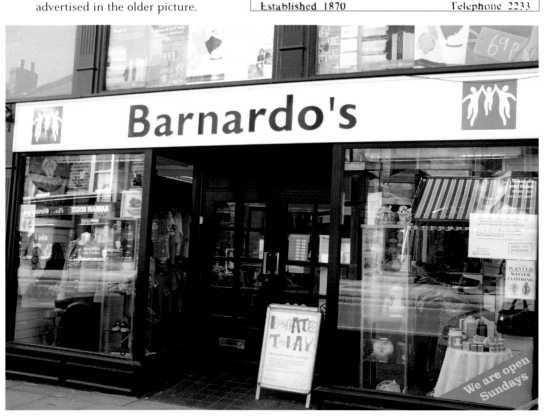

No. 10 Horse Market

The site of The Orchard (formerly Fruit Garden) was for the years 1851–1910 occupied by the serendipitously named Dennis Berry, hosier and draper. It then became the premises of J. Walker, caterer, before Mrs Brewer, another caterer, took over from the 1930s to the 1960s when it became 'Bernard's' fashions. T. Pease & Son, wine and spirit merchants had a brief spell here before 'Bernard's' fashions returned, to be followed by the current occupier over a decade ago.

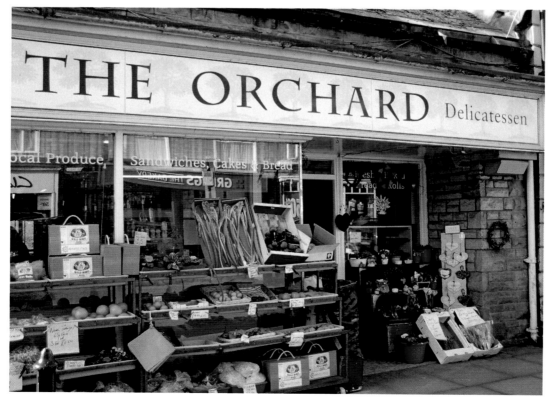

No. 4 Horse Market

These premises are today Star Flowers, but, previously, much of the trade from here attracted residents with a sweet tooth. John Davis was a general dealer; he was a grocer through the 1860s–80s until James Wrathall, painter, briefly occupied the premises in the 1890s. He moved to Queen Street for a few years before returning for a second spell. George Woodliffe Morton ran a confectionery shop here in the first decade of the twentieth century; he was followed by Misses Ellen and Jessie Stewart, pastry cooks and confectioners. They were succeeded by another confectioner, Cecil Henry Simpson, who also ran the Greta Café until the 1940s. Elliot's grocery and wholefood shop was at this site until towards the end of the last century.

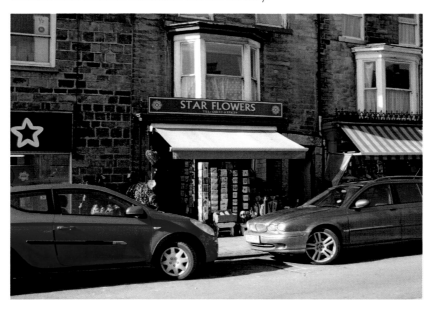

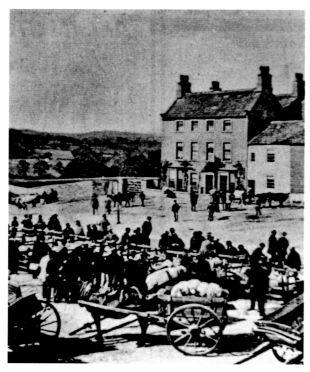

No. 2 Galgate

Market day in Galgate. The large white building has been the post office since August 1933. It was previously the residence of solicitor Richard Barnes from 1841 to 1851 and solicitor Ralph Coulthard in 1861. GP James Munro moved here after 1870; he was surgeon for the Durham Militia. In the 1900s Dr T. G. D. Adams was here until the post office took over.

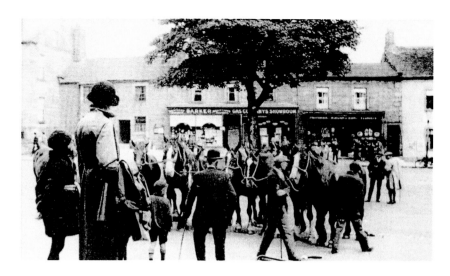

No. 6 Galgate

William Hall, a tallow chandler through the 1820s to the 1840s, handed over to Miss Elizabeth Hall and her grocery store; a welcome change for the neighbours as the smell caused by Mr Hall's candle manufacture from rendered animal fat must have been particularly unpleasant. It then reverted back to its former use – candle making – in the last decade of the nineteenth century through the business of Thomas Burton. He was followed by Mrs Mary Burton, baker and confectioner, and she in turn was succeeded Miss Lilla Burton, confectioner. She ran her shop for about fifty years. It was taken over by Mr D. Richardson, plumber, in the 1960s and 1970s. Today No. 6b is the site of Pampas, a fashion retailer. Barker's, plumber and gas showrooms, can be seen in the background of the older picture which shows a horse fair in Galgate; the fairs ran until 1939. W. Burn, fruiterer and florist, is to the right of Barker's.

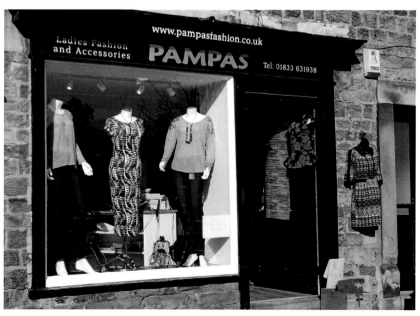

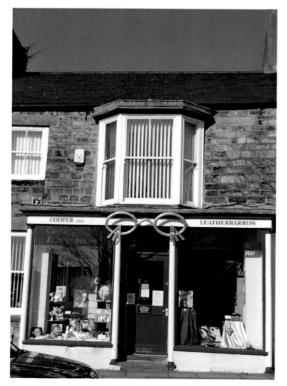

No. 8 Galgate

Shoemaker George Waistell worked here in the first half of the nineteenth century until rope maker Robert Ward took over in 1861. Rope making continued in the hands of William Ward and S. Breen, but by 1902 the shop had reverted to its former use – boot and shoe making, by E. Stoddart. For the next forty years it was E. Walker's hair salon, until taken over by Cooper & Leather, opticians, over fifty years ago. The advertisement illustrates the huge popularity of picture postcards in the late nineteenth and early twentieth centuries – entire shops were given over to their sale.

No. 10 Galgate

Sometime between 1835 and 1841 straw hat maker Ann Murray relocated her business from Bridgegate to this building in Galgate. Thomas Raper, watchmaker, worked here in 1851; twenty years later it had become a private house – residence of Susan Johnson. C. Hedley ran a plumbing business from here in the 1890s. Then M. Milner opened a grocery store here, which lasted for more than sixty years. The Book Aid Christian bookshop occupies it now and is one of the best specialist religious booksellers in Britain. Van Houten's Dutch-imported cocoa was very popular at the end of the nineteenth century and provided competition for the English companies Rowntree, Fry and Cadbury. It was Coenraad Johannes van Houten who invented the chocolate press that revolutionised cocoa and chocolate production from the 1860s (*see also page 51*).

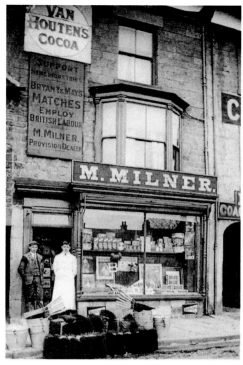

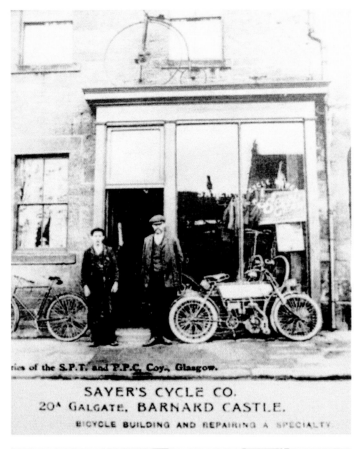

SAYER'S CYCLE CO.
20ᴬ GALGATE, BARNARD CASTLE.
BICYCLE BUILDING AND REPAIRING A SPECIALTY.

No. 20a Galgate
Close to the site of the former dining rooms and restaurants of M. Milburn, T. Mole, R. Dunn and Mrs Alice Hall in the 1800s were the cycle makers and repairers John and William Sayer. It is now The Vault, retailer of designer menswear.

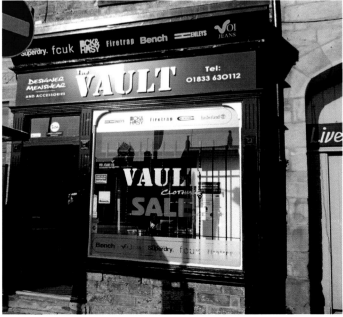

No. 30 Galgate

The current Register Office was formerly a private residence. Living here were Margaret Friary in the 1890s and Mrs Trery in 1902. Mr J. Wiseman must have put a smile on many local faces because this is where he made his artificial teeth in the early twentieth century. Brown's at No. 15, a grocer's since 1884, is advertising its coffee. The new picture shows gift shop Bohemia's splendid window at No. 66.

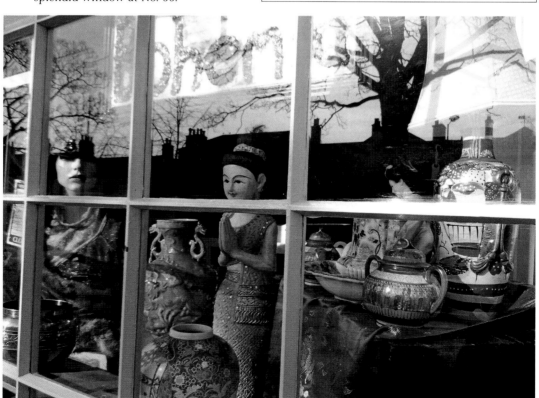

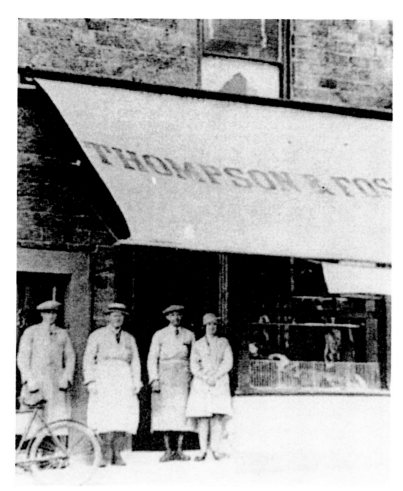

No. 32 Galgate
The location of Cornelius Metcalfe's grocery store in the mid-nineteenth century. He was followed by Benjamin Leech, a stonemason, and then by currier Edward Robinson. The shop was taken over by Thomas Thompson in the 1880s; he joined forces with William Henry Foster around thirty years later. By 1934 they also owned a shop in Staindrop. In 1938 customers could place an order with them in their Barnard Castle shop by telephone (telephone number Barnard Castle 75). In later years the premises has seen a change from food to clothing, and today is Nifty Nails.

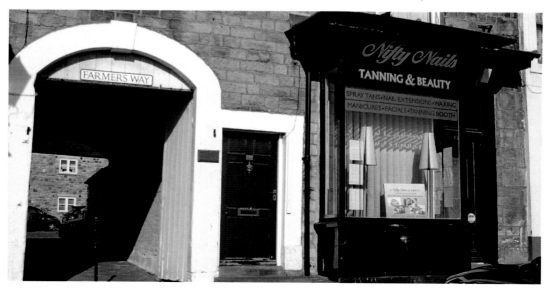

Barnard Castle Post Office

The post office is an important place in any town. The present location is No. 2 Galgate, but before this it has been in various parts of town. Barnard Castle actually had a 'posting office' in 1721, but what we now understand to be a post office was more properly founded in 1828 when it was located in Newgate and the postmaster was Robert Kipling. At this time letters from London, Manchester and Liverpool and 'all parts south of these places' arrived every morning at eight o'clock, via Darlington, and were despatched every evening at 6 p.m. via Greta Bridge. Letters from Edinburgh, Durham and Newcastle also arrived at 8 a.m. and were despatched at 4 p.m. Letters from Glasgow, Carlisle and the West, Leeds, East and North Ridings arrived at 'thirty-five minutes after six in the morning', and were despatched at 6 p.m.

1930's

Postal Information.

MONEY ORDERS (INLAND).

Money Orders can be obtained at every Post Office where there is a Savings Bank. The commission for sums not exceeding £3, 4d.; for sums above £3 and not exceeding £10, 6d.; for sums above £10 and not exceeding £20, 8d.; for sums above £20 and not exceeding £30, 10d.; for sums above £30 and not exceeding £40, 1s.

Orders void if not presented for payment within 12 months.

TELEGRAPH MONEY ORDERS.

Same as above, with supplementary fee of 2d. and cost of Telegram.

POSTAL ORDERS.

Postal Orders can be purchased at nearly all Offices in the United Kingdom, upon which poundage is charged as follows :—

0/6...1d.	7/6...1½d.	14/6...1½d.
1/0...1d.	8/0...1½d.	15/0...1½d.
1/6...1d.	8/6...1½d.	15/6...2d.
2/0...1d.	9/0...1½d.	16/0...2d.
2/6...1d.	9/6...1½d.	16/6...2d.
3/0...1½d.	10/0...1½d.	17/0...2d.
3/6...1½d.	10/6...1½d.	17/6...2d.
4/0...1½d.	11/0...1½d.	18/0...2d.
4/6...1½d.	11/6...1½d.	18/6...2d.
5/0...1½d.	12/0...1½d.	19/0...2d.
5/6...1½d.	12/6...1½d.	19/6...2d.
6/0...1½d.	13/0...1½d.	20/0...2d.
6/6...1½d.	13/6...1½d.	21/0...2d.
7/0...1½d.	14/0...1½d.	

Broken amounts can be made up by Postage Stamps, not exceeding two in number, to the value of 5d., affixed to the face of the Order.

All Orders must be presented for payment within three months of the last day of the month in which they are issued.

PARCEL POST.

For a Parcel not exceeding 2lb. in weight, 6d. ; exceeding 2lb. but not exceeding 5lbs., 9d. ; exceeding 5lbs. but not exceeding 8lbs., 1/- ; exceeding 8lbs. but not exceeding 11lbs., 1/3.

The maximum weight is 11lbs. The size allowed for an Inland Parcel is —greatest length, 3ft. 6in. ; or length and girth combined, 6ft.

LETTER POST.

For Letters not exceeding 2oz., 1½d. ; for every additional 2oz. or fraction of 2oz., ½d.
No letter to be above 24 inches in length, 12 inches in width, and 12 inches in depth.

TELEGRAMS.

The charge is 1/- for the first 12 words and 1d. for every additional word. Five figures are counted as one word. The address of the receiver is charged for. Free delivery if within three miles of Post Office, and 6d. each mile, beyond three miles. Inland telegrams handed in on Sundays, Good Friday, and Christmas Day will be charged 6d. extra.

EXPRESS DELIVERY

of Letters and Parcels, a fee of 6d. for every mile or part of mile.

PRINTED PAPERS.

For every 2ozs. or fraction thereof ½d., maximum 2lbs.

NEWSPAPER POST.

For each registered Newspaper, 1d. for every copy not exceeding 6oz. in weight, with a further charge of ½d. for every additional 6oz. or fraction of 6oz. No packet to be more than 2lbs in weight, 2ft. in length, 1ft. in width or depth.

REGISTRATION FEE.

The fee in addition to postage on an inland letter, parcel, or other postal packet is 3d. for £5, 4d. for £20, and 1d. for each additional £20 up to £400.

FOREIGN POST.

The rate of postage is 2½d. for the first oz. for letters, and 1½d. for each succeeding oz. or part thereof ; and ½d. per 2 oz. for newspaper, books, and other printed papers. Registration fee, 3d. Letters for British Colonies, Egypt, United States of America, Tangier 1½d. for the 1st oz. and 1d. for each additional oz. or fraction thereof.

STAMPS.

Books of ½d., 1d. and 1½d. stamps are now on sale at 2/-, 3/- and 5/- a book.

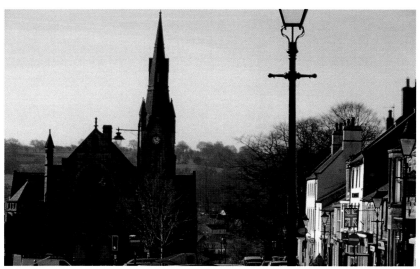

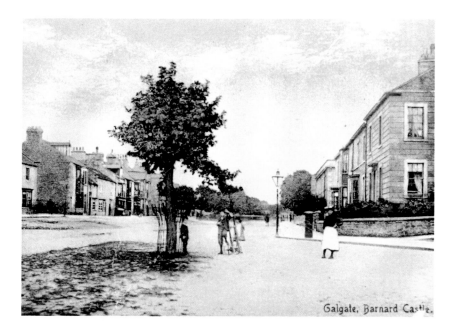

Galgate, Barnard Castle.

Galgate

In 1835 the post office was still in Newgate, with the postmistress Sarah Kipling. Posting boxes closed half an hour before the despatch of the mails, after which time one penny had to be paid with each letter. In 1870 it became the 'Post and Money Order and Telegraph Office, Post office Savings Bank and Government Annuity and Insurance Office', overseen by John Monkhouse, postmaster. Letters arrived from London, the North and Darlington at 8.15 a.m., and were despatched at 11.40 a.m. and 5.15 p.m. By January 1876 it was the head post office and in 1879 was still under John Monkhouse. Galgate, as the card shows, was the place to live in the early twentieth century.

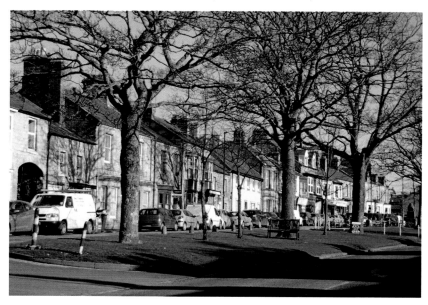

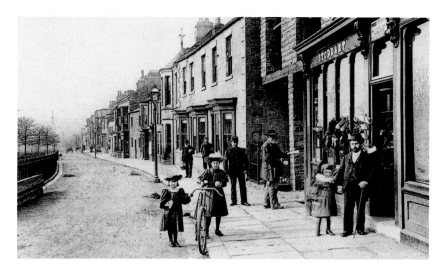

No. 84 Galgate

No. 84 Galgate was the site of the post office at the beginning of the twentieth century, run by Mrs M. Stoddart, along with her newsagent's and shoe warehouse, and in 1933 it moved to its present location at the bottom of Galgate. On Wednesday 27 September 1933 the *Teesdale Mercury* lamented the fact that it was the date of the last horse-drawn post cart in Upper Teesdale. However, between 1935 and 1958 there was an additional sub post office at No. 24 The Bank. The building under construction next to Stoddart's in 1895 became E. A. Metcalfe's, photographers, and then Dalston's Cycles from 1925. Today, Spitfire Cycles at No. 44 is shown in the new photograph.

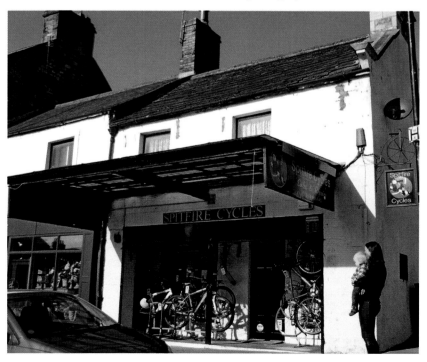

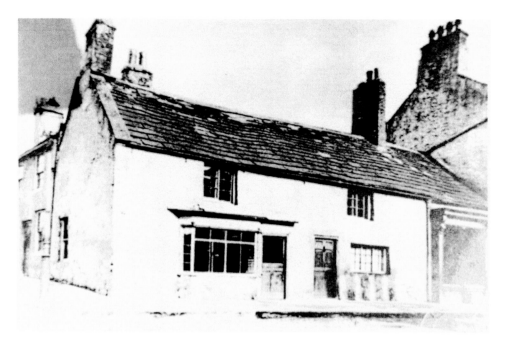

No. 1 Galgate

Galgate, as the name suggests, was a former gallows site. Sometime between 1835 and 1851 tailor and grocer M. Bland moved from The Bank to this building. It remained with Miss Ann Bland into the early twentieth century. Dentist H. Tibbits looked after residents' teeth before the premises became a clothes shop, silversmith and more recently Floral Charm. The Kartoon Shop owned by H. R. Wood, a snack bar also selling gifts, occupied the site in the sixties.

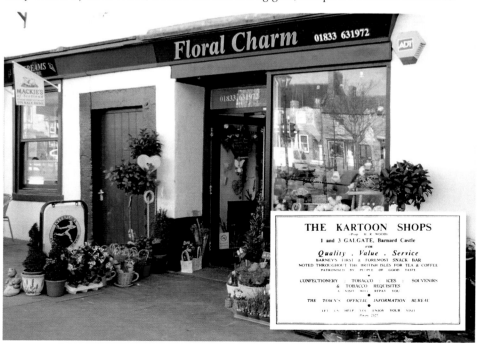

No. 13 Galgate

Living here on her 'own means' in 1851 was a lady described as 'J Lax's aunt'. Christiana Appleby owned this building and the land in 1861. J. Bainbridge, photographer, occupied the premises in the 1870s (moving from his studio on The Bank). He was followed by the better-known Elijah Yeoman, who made his living from photographing families and individuals; some of his wonderful landscape photographs can be seen in the Bowes Museum. He photographed Princess Eugenie of Battenburg when she visited Raby Castle in 1905. Yeoman was succeeded by R. Sweeten in the 1920s. Two of his portraits are shown here; one of an elegant young lady, the other a mother and son.

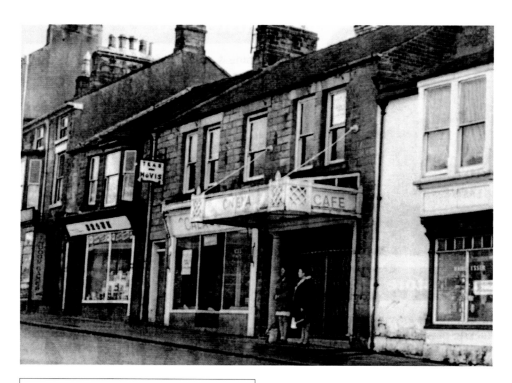

No. 13a Galgate

The Scala Cinema was at the rear of the building. It was opened in May 1924 and closed in June 1971. Matinee shows were at 2 p.m. with evening shows at 6.30 p.m. and 8.30 pm. During the late 1920s and into the 1940s people could eat in the Scala Café at No. 13, which was run by C. W. Watson, a native of Barnsley. He joined the Army at seventeen and survived the First World War, but died in 1933; his wife carried on running the Scala Café. They offered 'seating for 70 people' and music as pre-cinema entertainment. After the Scala closed, the building was used as an auction room. No. 13 became Addison's estate agent's.

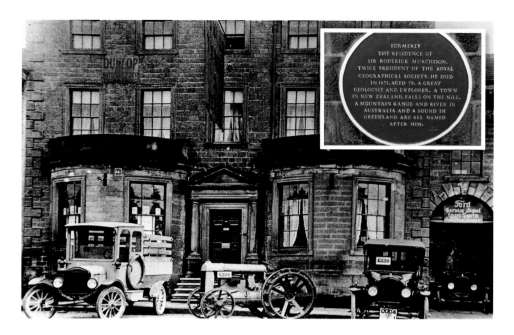

Nos 19 & 21 Galgate

The cars on sale here are in front of the salerooms and offices of Louis Smith Motors – occupants of these premises since their move from No. 73 Galgate sometime between 1910 and 1920. Family trading then continued from here for 100 years until early 2012, when Blenkiron's Funeral Directors moved their business to No. 19 from No. 100 Galgate. The plaque shows this as the home of Sir Roderick Murchison, explorer extraordinaire.

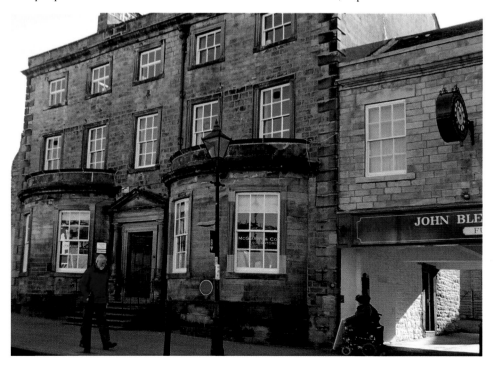

C. HEDLEY, R.P.

(Member of the Most Worshipful Company of Plumbers, London),

PAINTER, GLAZIER, AND GENERAL CONTRACTOR,

17, GALGATE, BARNARD CASTLE.

LEAD AND IRON LIFT AND FORCE PUMPS
A SPECIALTY.

LAMP OILS. | ESTIMATES GIVEN FOR ALL DESCRIPTIONS OF WORK.

GALVANIZED ROOFS SUPPLIED.

INCANDESCENT GAS LIGHTS SUPPLIED

(WELSBACH PATENT)

AND ALL FITTINGS.

Nos 23 & 25 Galgate
In a remarkable show of continuity, the site now occupied by Morrison's supermarket is to the rear of what was the Hedley family blacksmith's workshop, which was here for more than a century until the mid-twentieth century. No. 25 was demolished to create access for the car park; the premises had been variously occupied by J. Kennedy, watchmaker (moved to No. 27), M. Elliott, confectioner (also moved to No. 27), J. Milliner, greengrocer, J. Duffy, confectioner, and Mrs M. Cole, confectioner.

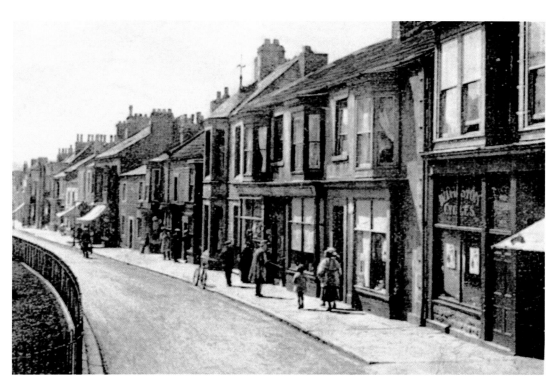

The Boer War Memorial
Dalston Cycles can be seen on the right here in this 1925 postcard; Metcalfe the photographer had preceded them. Dalston's was opposite the Boer War memorial.

No. 27 Galgate

Meynell's pet and garden supplies now occupies the site of what was J. Kennedy's watchmaking and fancy goods store in the last years of the nineteenth century. It was the location of M. Elliott's confectionery shop in the 1930s, Raine's farm shop later in that decade, followed by Jenkinson's radio, television and electrical contractors. This place marks the site of the former boundary of the cattle market.

THIS HOUSE IS THE BIRTHPLACE
(30 JULY 1909)
OF
CYRIL NORTHCOTE PARKINSON,
AUTHOR,
PROFESSOR OF VARIOUS UNIVERSITIES
AND DISCOVERER OF
PARKINSON'S LAW WHICH READS:
'WORK EXPANDS SO AS
TO FILL THE TIME AVAILABLE
FOR ITS COMPLETION'.

No. 39 Galgate

Barnard Castle was never short of dental surgeons, and continuing the tradition Castle Dental Practice now occupies these premises. Before this it was a private residence, being home to S. Edgar in 1835, Margaret Watson in 1873 ('landowner'), J. H. Jones in 1890, and between 1902 and 1910 E. Dalkin ran it as a lodging house. For a brief spell it was in use by Addison's auctioneers. Cyril Northcote Parkinson, historian and satirist, was born at No. 45 Galgate; he died in 1993. In between times he fought a lifelong battle against bureaucrats and bureaucracy and fully deserves his blue plaque. Apart from the famous law quoted here, he also came up with 'expenditure rises to meet income'.

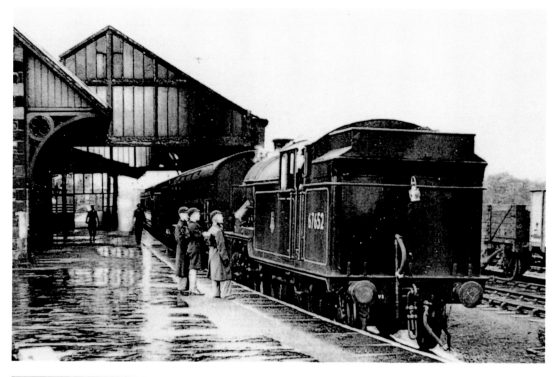

e Tees at Barnard Castle

TEESDALE

BRITISH RAILWAYS SEE BRITAIN BY TRAIN

The Railways

After much procrastination and opposition from local landowners, notably the Earl of Darlington, the railway finally arrived at Barnard Castle in 1856 with the first station sited near to where the Montalbo Hotel is now; this became a goods station in 1862 when a new station opened where GlaxoSmithKline's car park now is, on Harmire Road. The line was on the South Durham & Lancashire Union Railway between Bishop Auckland and Kirkby Stephen. Apart from tourists, the railway brought employment for local people and navvies from afar: Surrey, Kent, Somerset and Scotland, for example, as well as from Ireland. Coach services from the station sprang up taking passengers to Brough and Middleton, and to the Kings Head in town. The railway closed to passengers in 1964. Freight continued to make it by rail to Barnard Castle for another year, but then that too became a casualty.

No. 7 Horse Market

This building was formerly the site of the drapery-outfitters owned by the Winpenny family. Richard Winpenny, woollen draper, was born in 1793 and by 1835 had established a thriving business in Barnard Castle. He died in 1844; the business was taken over by his son Francis – a young man in his early twenties. He built up the business, in addition to being the local insurance agent for the British Empire Mutual Company. By 1881, Winpenny & Sons employed nine men and one boy (his son Joseph was a tailor-draper); his twin sons Albert and Ernest were employed as assistant drapers. Joseph took over the business after Francis's death until 1921, when nearly ninety years of family trading ceased and J. Marquiss, outfitter, moved in. The new picture shows *Barnard Castle & Teesdale Through Time*, published in 2012 and available from the *Teesdale Mercury* shop.

PAUL CHRYSTAL
BARNARD CASTLE & TEESDALE
THROUGH TIME

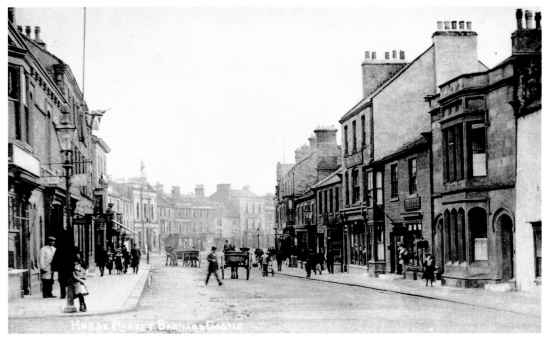

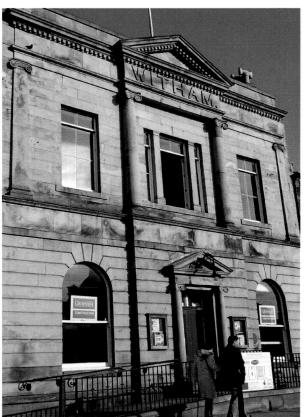

No. 5 Horse Market

In the 1930s the building was rebuilt; there was some overlap with No. 5, occupied by the Yorkshire Penny Bank since 1902. Reconstruction took nearly eighteen months, during which time banking was carried out in the Witham Dispensary next door; there was also a small lending library there. The Yorkshire Bank (minus the Penny) operated in No. 5; No. 7 became Smithy's hairdresser's. The Yorkshire Bank vacated and the premises became a bookmaker's. Parkinson's is on the right; the Witham and signs to the station and to the woods are on the left.

No. 9 Horse Market
The site of Hamilton's (Clark's Shoes) has long been a place to purchase footwear. Joseph Hall, bootmaker, moved here from No. 1 in the late 1840s. His son Jonathan was a master druggist and the premises became a saddlery in the 1860s. Another bootmaker, John Carter, moved in during the 1870s and a 'Boot and Shoe Warehouse' was opened by John T. Pearson in the 1890s. He was here for more than thirty years until boot and shoe dealer Robert Anderson took over in the early 1930s. He also offered chiropody under the personal supervision of Eric Watson MNChA. Anderson was still dealing in footwear here in the 1980s.

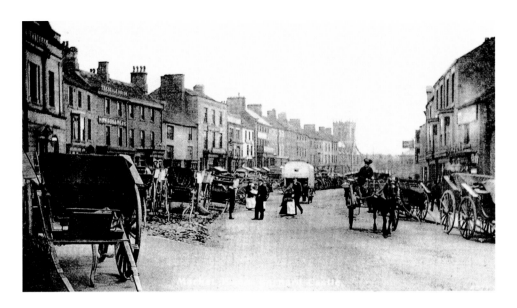

No. 13 Horse Market

Clothing has played an important role in these premises since the early 1800s. In the 1820s tailor W. Riddle worked here for thirty years until he was followed by another tailor, Thompson Gunson, in the 1850s. He in turn gave way to tailor-draper William Sang in the 1860s; he was succeeded in the 1870s by William Knox, who sold baby linen. Henry Appleby, draper, took over in the early years of the last century and after some twenty years of trading handed over to Joseph Swinbank, draper and outfitter. In the 1950s C. Newton, ladies and children's outfitter, operated from here (telephone number Barnard Castle 37). Clark & Hall gents outfitters occupied the premises in 1980 moving to Star Yard in the 1990s when Edinburgh Woollen Mill moved in. Teesdale House is on the left.

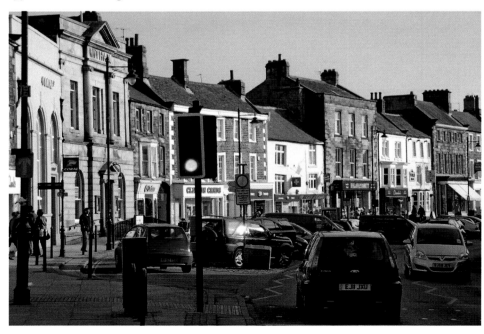

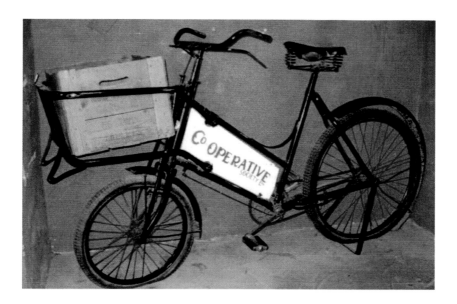

No. 17 Horse Market

The Co-op has occupied these premises since the 1950s. The building has changed hands only four times since the 1820s, when Ralph Simpson traded glass and china here until the 1870s. The site then became a grocery-confectionery shop run by William Hodgson, taken over by George T. Burt in the 1930s until the arrival of the Co-op.

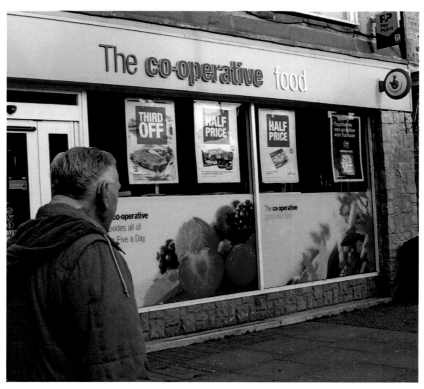

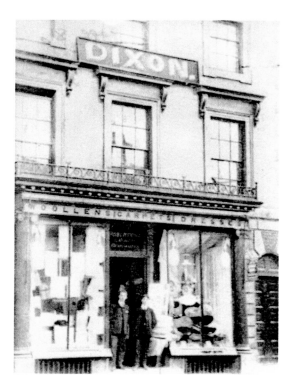

No. 23 Horse Market

For over 100 years from 1803 this building was the site of the Dixon family business, variously grocers, drapers, linen drapers, and silk mercers. William Dixon's will was proved in York on 15 January 1830 and the business passed to his son, Joseph Dixon. In 1871 Joseph and his wife Sarah had one apprentice 'living-in' and two housemaids. By 1881 the business had been taken over by the eldest son Michael; the business was evidently flourishing, as Michael had an assistant draper 'living-in', a cook, domestic servant, housemaid and employed four males and eight females, including a nurse. In the early 1900s the business was taken over by Robert Ord, draper and milliner, succeeded by Blackett's drapery and department store in the 1930s for about forty years. Today it is the site of Stead & Simpson Shoes. The new picture shows Peat's the butcher's at No. 29; Peat's delicatessen is a couple of doors away.

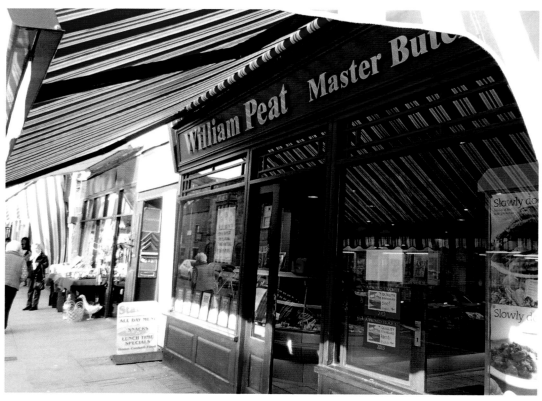

VACANT POSSESSION

TO LET

APPLY TO

THOS. K. BELL

HOUSE & ESTATE AGENT

25, Horse Market, Barnard Castle

Nos 27/27a/25 Horse Market

What has been the Hayloft Emporium for twenty years – a treasure trove of bric-a-brac, antiques and collectables, a restaurant and a grocery store – formerly had a variety of uses and businesses. G. Longstaff, carrier, operated from here in 1841; in 1851 it was the site of butcher George Dalston. It changed to Ann Dalston in 1861, and it was an ironmongers until the 1870s when iron founder John Sinclair moved in. The Walker family's saddlery business was situated here between around 1890 and 1921, after which milliner Miss Rudd was trading, and also selling gowns and knitwear. In 1934 E. W. Willis, saddler, was at No. 27a. Through the 1970s and '80s Elizabeth's 'Ladies' Fashions' occupied part of the building.

11th May, 1904; Police Court Proceedings; Case Dismissed.

20th Dec., 1905; Appeal to High Court; Dismissed with Costs.

No. 29 Horse Market

From 1828 to the 1890s this building was the site of a rope, twine and sacking maker's owned by the Dalkin family. The building was for a short while in the hands of jeweller and music teacher Robert Racher. In 1921 J. Walton & Son, tailors, were followed by Mrs Gray, florist. The Peat family located their butcher's shop here (*see page 84*). Fruiterer and poulterer George Harris had his shop in Horse Market – perhaps the 1905 report in the *Newcastle Chronicle* puts it best: 'A Barnard Castle tradesman was confronted with a blood-curling [sic] spectacle on drawing his blind one morning recently. He had erected a new window in his premises without the sanction of the Urban Authority.' Someone had mischievously moved the Boer War gun from Galgate to aim at the defiant George Harris' window in Horse Market and put up a notice demanding that he 'surrender or die'. Harris responded with 'no surrender' and was known as 'No Surrender Harris' ever after.

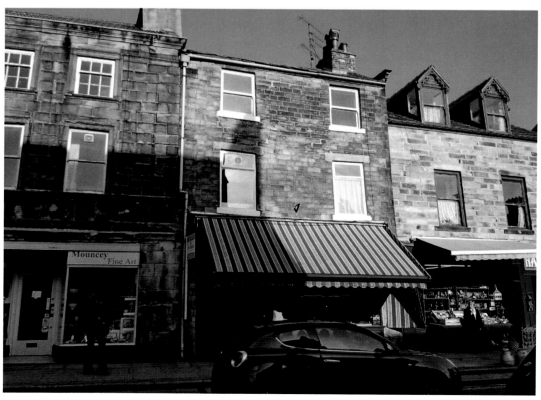

No. 33 Horse Market

For more than twenty years the Gofton family ran their hairdresser's and general store from here until they were followed by school mistress and registrar Jane Appleby in the 1850s–60s. J. Thompson & Son, cloggers, moved here from The Bank at the very start of the twentieth century, succeeded by Ada Brown, who ran her tobacco and confectionery shop in the early 1900s. The business then passed to John, who ran the same business for another twenty years. He was succeeded by 'Mrs P's Home Made Cakes'. Currently it is Gentian, glass engravers. This business has been helped by local group The Vision to create new outlets in town on a 'shop-share' basis. The old pictures here and on page 88 show attractive Thompson trade cards.

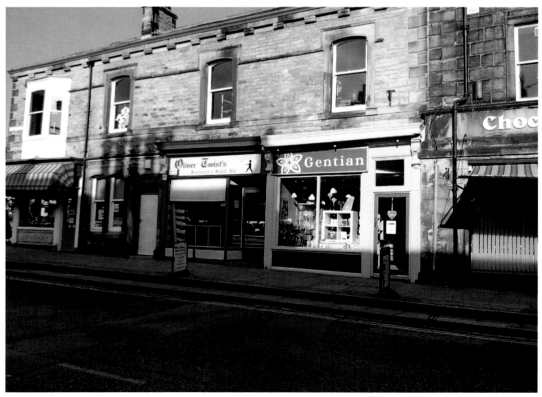

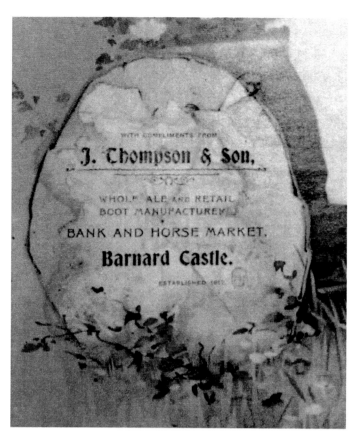

No. 37 Horse Market
These premises on the corner with Galgate were, until 1897, the warehouse for Thompson & Son, cloggers and shoemakers. George Johnson, butcher, moved here from No. 46 The Bank in 1879 and remained until shortly after the First World War, after which he was followed by another butcher, Herbert Young. Today it is the site of McFarlane's family butcher's.

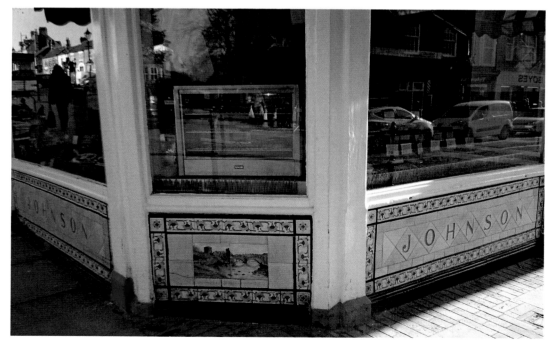

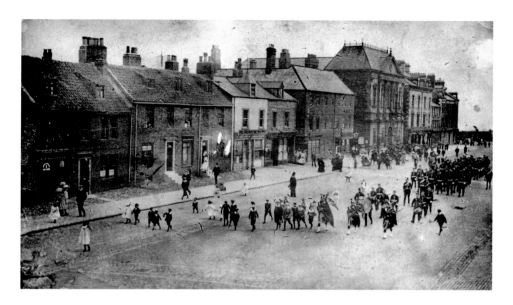

The Witham

Henry Witham (1779–1844) of Lartington was a benefactor, philanthropist and eminent geologist. He founded the Mechanics' Institute in 1832 to provide education for the working classes so that they would develop a desire to pursue knowledge and thereby 'improve themselves'. He also helped to set up a Dispensary Society, which offered assistance to people who could not afford doctors' fees by providing medical help and medicines. To assert their philanthropic credentials many of the local traders, businessmen and professionals became involved with the running of the Mechanics' Institute. The Witham is the large building to the right of the picture.

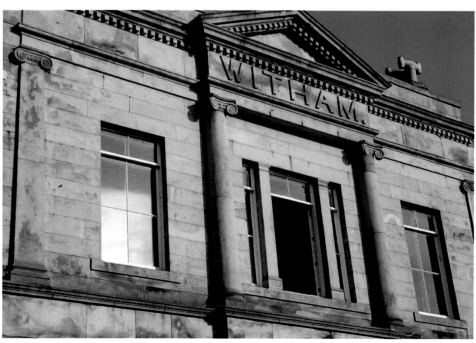

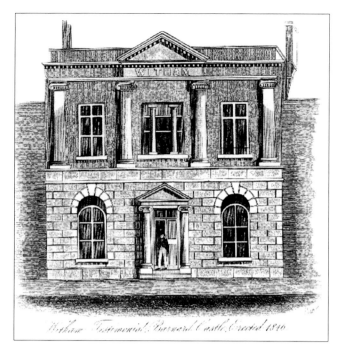

'The Mineral Resources of Teesdale'

In 1835 George Knox was secretary and Joshua Monkhouse, carpet manufacturer, was the treasurer. Henry Witham was very keen for a purpose-built building to be erected to house the Institute and, after his death in 1844, the Witham Hall was built by local public subscription as a tribute to his aims and his memory. In 1861 John Clarke was the librarian of the Institute – it boasted 2,700 volumes at this time. During the 1860s, two notable lectures were given at the Institute reflecting Henry Witham's interests in geology – both given by a Mr Pinkney. The first was 'The Mineral Resources of Teesdale' and the second was 'The Geological Aspects of Teesdale'. The *Teesdale Mercury* reported that this second lecture was one of the best ever presented at the Institute and that despite the cold, wintery night there had been a very good number of people attending. By the 1880s the Institute had over 3,000 volumes and had reading facilities open to the public. In 1921 women came on the scene when Miss Dora Monkhouse became secretary, later taking over the running of the library. The Witham Hall continues to be a hub of the community and recently the regeneration organisation 'Barnard Castle Vision' and the Trustees of the Witham Hall have completed work to conserve the building and expand the facilities on offer so that it remains the asset to town that Henry Witham envisaged over 150 years ago. The older image shows the Witham in Garland's *Tour of Teesdale* (1852); the newer one depicts the fine window on the staircase in the Testimonial Hall in 2013.

WM. SMITH,

LOW MILL FOUNDRY, BARNARD CASTLE,

SOLE MAKER of the HOT-AIR KITCHEN RANGE, on an Improved Principle (Patent) OVENS alone if required; also the GLENDENNIN or Ordinary HOT AIR RANGES, Cast Iron Ovens Boilers, Water Troughs, Pig Troughs, Washing Machines, Wringing Machines, Machinery, Casting for Machinery of every description; Spouting Fencing, Railing, Corrugated Sheets for Roofing Wire Netting. IRON AND BRASS FOUNDER A Large Assortment of Ironmongery of ever description.

William Smith & Sons

It would be impossible not to mention William Smith in any commercial history of Barnard Castle. Mr Smith invented a horse-drawn road-sweeping device in the 1830s; his company grew from this to become one of the major employers in the town. The new image shows one of the company's range of commercial signs today, some 100 years after the old advertisement was published.

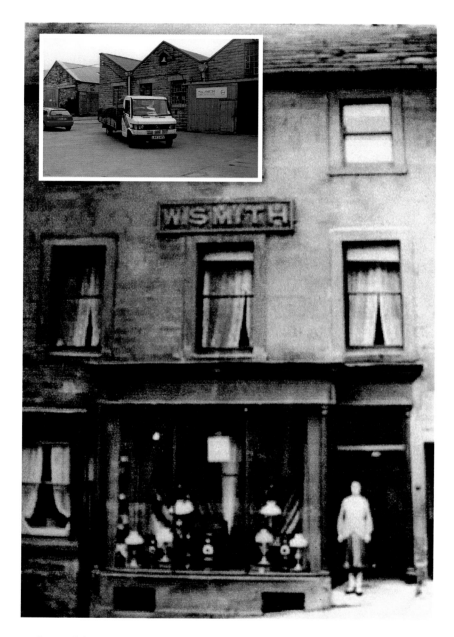

Makers of the Patent Street Sweeper and Street Scraper

The company has variously been described in directories and census returns as:
William Smith, Blacksmith and Whitesmith, Market Place (1851); Shoeingsmith,
Queen Street (1861); William Smith and Sons, Brass and Iron Founders (1873);
William Smith & Sons, Ironfounder and Patenters and Makers of the Patent
Street Sweeper and Street Scraper, (1877); and Brass and Iron Founders (1879).
In 1934 the company began to produce cast-iron road signs and in the 1950s
reflective road signs. The 1960s and 1970s brought logos and vinyl lettering.
Today the company is still a family concern and is in the hands of the seventh
generation at their Grove Works in Queen Street.

Prostitution

While Barnard Castle appears for a large part to have been genteel and mainly law-abiding, there can be no escaping the fact that the presence of the militia would have encouraged and supported prostitution. In 1858 Mary Macarty, a Leeds-born prostitute plying her trade here, was charged with 'stealing from the person of John Race' – probably an act of opportunist theft on her part. In the same week in October Marie Campbell, from Scotland, was charged with 'soliciting women for prostitution in Barnard Castle'. In 1861 two known prostitutes were both charged with 'robbing', and in the same year Margaret Wilson and Ann Franklin turned the tables and charged Thomas Blackburn with causing a breach of the peace by accusing them of being prostitutes. Throughout the 1860s and 1870s there were several reports of 'want of discipline' and 'riotous behaviour' by certain recruits in the militia on duty at Barnard Castle and billeted at beerhouses in town. It is probably unsurprising that at the same time as their presence there are numerous reports of 'quarrelsome behaviour', and incidents of women of 'dissipated and intemperate habits' being drunk and disorderly, accused of various felonies and charged with being common prostitutes. One quarrel by two women in town was said to contain 'language most disgusting' and both were fined 4d. Mary Meynell assaulted Mary Brown and was fined half a crown. The card shows how far women had come in the employment stakes, inappropriately dressed and with men still on top for the most part...

The Changing Role of Women in Barnard Castle

Residential properties were often converted into businesses to generate more income, usually for those already financially comfortable, as shown by these examples from the 1870s: Jane Hepworth, wife of Benjamin Hepworth, a builder employing fourteen men, ran a lodging house in Galgate; Margaret Perkins, spinster, had a lodging house in Galgate with her mother Mary, who received an income from an annuity; Elizabeth Robinson, who had 'money at interest', ran a lodging house, also in Galgate, with her brother George, a house proprietor; and Eliza Steele, together with her father Richard, a landowner from Darlington, ran a lodging house in King Street. In the twentieth century there is evidence that some women were branching out into other occupations and minding their own businesses, including ladies' outfitters, fruiterer's, newsagent's, insurance agent's and bookseller's. After the First World War women are listed as running apartments, shopkeepers, cow keepers, managing fancy repositories, dressmakers, grocers, booksellers, ironmongers and plumbers, confectioners, bakers, drapers, running newsagents, nurses, laundresses, artificial fly dressers, running refreshment rooms, milliners, fried fish dealers, secretary of the Mechanics' Institute, Secretary of the Soldiers' and Sailors' Families Association, and proprietress of the Vulcan Sole Company. Ms Chris Anderson's Silver Slipper was popular with the Royal Military Police stationed at Deerbolt Camp; note the added attraction of 'international and local beauties'.

The roles traditionally played by women are well documented in the trade directories throughout the last 180 years. During the first half of the nineteenth century women were running academies and day schools; they were also shopkeepers (confectioners, pawnbrokers, innkeepers, straw hat makers, dressmakers and, in one rare instance, Ann Johnston is listed as a stonemason). The professions of banker, manufacturer and auctioneer were exclusive to men, and out of twenty-five shoemakers in Barnard Castle in 1851 only one was a woman – Anne Middlewood on The Bank. By the 1890s one woman, Miss Sarah Longbottom, appears as the secretary of the Co-op, but the range of female occupations in Barnard Castle in the 1890s is almost unchanged from fifty years earlier. The number of women running lodging houses and apartments rose steadily as the town's population increased following on from the building of the gasworks, the opening and expansion of the textile mills, and the railway.

Miss Lilian Thornton

ARTIFICIAL FLY DRESSER

63, GALGATE

Special Patterns copied . .
Best Quality Casts.

Salmon and Loch Flies.

Lightly Dressed
North-Country Flies.

The Silver Slipper
Snack Bar
(Proprietrix Chris Anderson)

VARIETY OF

SANDWICHES . CAKES . MINERALS . CONFECTIONERY
HAMBERGERS . COCA COLA
CIGARETTES

Minstrel JUKE BOX playing popular music
with choice of hymns on Sundays

PIN-UP GALLERY OF INTERNATIONAL
AND LOCAL BEAUTIES

The Vanished Trades of Barnard Castle

Modern high streets are forever changing; businesses come and go. Barnard Castle is no different. Here are a few of the vanished trades and businesses that are unlikely to make a reappearance anywhere in the town: chymist, druggist, grocer and gingerbread baker (Henry Raine, 1828, Bridgegate); flax dresser and tea dealer (Joseph Hildreth, 1828, Newgate); ironmonger and jeweller (Michael Johnson, 1828, Market Place); draper, grocer and dealer in hats (Cherry and Thomas Buckle, 1828, Horse Market); chymist, druggist, grocer and brewer (Hannah Heslop, 1828, Market Place); nailmaker (George Cooper, Robert Murray, Thomas Softley, George Ware, 1828, various locations); ivory turner (John Binks, 1828, Thorngate); licensed to let hack horses (John Hodgson, 1828, Market Place); stay maker (Elizabeth Weaver, 1851, Bridgegate); straw bonnet maker (Martha Green, 1851, George Street; Jane Percival, 1851, King Street); patten maker (William Howden, 1861, The Bank); skin merchant (Francis Capstick, 1873, Bridgegate); Berlin wool warehouse (William Knox, 1877, Horse Market); bird preserver (Robert Carter, 1877, Bridgegate); bird stuffer; (Thomas Harrison, 1877, Thorngate); Town Crier and bill poster (James Wright for several years); fancy repository (Mary Peart, 1910, The Bank); artificial teeth maker (John Wiseman, 1921, Horse Market); yeast merchant (Ralph Pratt, 1934, The Bank); wireless dealer (Harold Turner, 1938, Horse Market). We still have grocers but their role has changed completely – in the early twentieth century it was a skilled business requiring a long apprenticeship and expertise in teas and coffees, meats and cheeses, and catering for all levels of society, as this card shows.